# HOVE &
# PORTSLADE
## THROUGH TIME

# HOVE & PORTSLADE

## THROUGH TIME

Judy Middleton

AMBERLEY PUBLISHING

# Acknowledgements

Thanks to Robert Jeeves of Step Back in Time, Queen's Road, Brighton, for allowing me to use the 1914 view of George Street.

First published 2009

Amberley Publishing Plc
Cirencester Road, Chalford,
Stroud, Gloucestershire, GL6 8PE

www.amberley-books.com

British Library Cataloguing in Publication Data.
A catalogue record for this book is available from the British Library.

ISBN 978 1 84868 416 4

Typesetting and Origination by Amberley Publishing.
Printed in Great Britain.

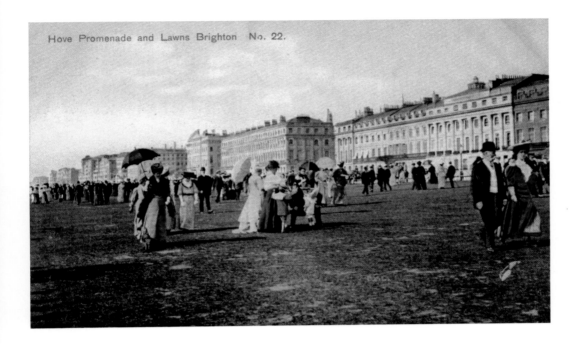

# Introduction

There is a standard joke that when Hove people go abroad and are asked where they come from, they reply 'Brighton – well Hove actually.' But Hove does not need to make apologies for itself because it has its own character and has managed to retain it despite being amalgamated with Brighton since 1997.

Some of the photographs were taken during a very cold spell in January 2009 but there is a historical resonance. The Victorians were quick to appreciate the qualities of a fine winter's day at Hove especially when compared with the notorious fogs prevalent in London. Indeed Hove was promoted as a healthy place to live and it expanded rapidly in the nineteenth century with the population rising from 2,509 in 1841 to 29,695 in 1901.

Another reason for its popularity was the fast and efficient train service to London. One of the earliest films ever made was shot in 1897 by George Albert Smith and was called *Passenger Train*. It showed people alighting at Hove Station.

The reason Smith based his endeavours at Hove was because he needed good natural light in order to film. He rented St Ann's Well Gardens and set up his studio there.

St Ann's Well Gardens had health connotations too because the waters of its chalybeate spring were famous and thought to have healing powers. Queen Adelaide and Princess Augusta, daughter of George III, were amongst the elite who came to sample the waters. Mrs Fitzherbert was another fan.

Royalty put Brighton on the map so to speak and the benefit travelled across the boundary to Hove. When Brunswick Town was developed in the 1830s and 1840s aristocratic residents considered that they were living in Brighton. In later years even the schoolboy Winston Churchill headed his notepaper with 'Brighton' rather than 'Hove'.

The imbalance of sexes was an interesting feature too. For example in 1901 at Hove (excluding Aldrington) there were 18,931 resident females as opposed to 10,764 men. This was thought to be because of the 'large number of female servants attached to families of resident gentry.' There were also wealthy widows and ladies of independent means.

The place to be seen on Sunday mornings (after church of course) were the Brunswick Lawns where ladies and gentlemen promenaded in their very best attire and a newspaper reporter was on hand to report on the latest fashions. Fortunately for us many of the postcards depicting this scene were coloured, adding a nostalgic touch and the inspiration for this book.

Portslade could not be more different from Hove. For centuries Portslade was the more important parish with 2,780 acres compared with Hove's measly 778 acres. Portslade had a manor house dating back to Norman times and a larger population. The balance shifted in the nineteenth century. Hove acquired the parishes of Aldrington, Hangleton and West Blatchington and became fashionable and wealthy. Portslade remained much the same relying on farming and market gardens and in later years taking in Hove's dirty laundry. Industry thrived in the south part with men earning their living at the gas works, electricity works or brick fields but there were only a few mariners. In contrast to Hove's largely transient population, many Portslade families had been resident for generations. Portslade was joined to Hove in 1974.

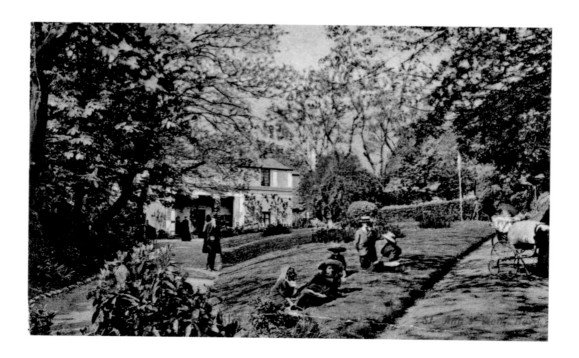

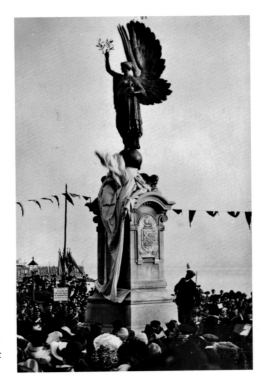

## The Peace Statue

Within a few months of King Edward VII's death Hove Council decided upon a memorial statue. The plaque records 'a testimony of their enduring loyalty' but it was also a reminder of the king's visits to Hove. Brighton soon joined in and Newbury Trent's creation was unveiled in 1912. It cost £900. In the recent view part of the angel's olive branch is missing.

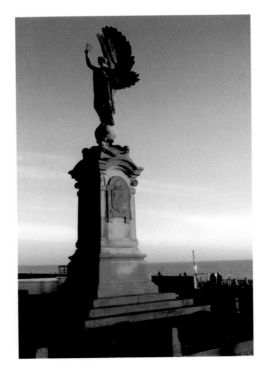

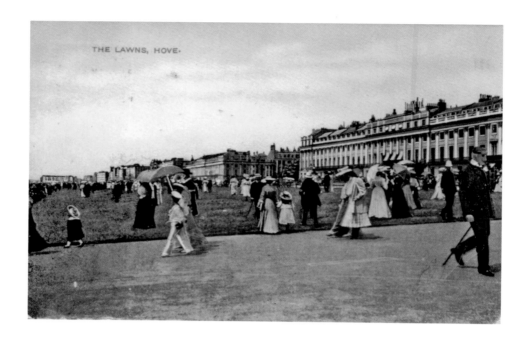

THE LAWNS, HOVE.

## Brunswick Lawns

Work on the foundations of Brunswick Terrace started in 1824 and two years later the first few were ready for letting as furnished houses. Brunswick Lawns were once the preserve of Brunswick residents but by Edwardian times other people could stroll there on a Sunday morning.

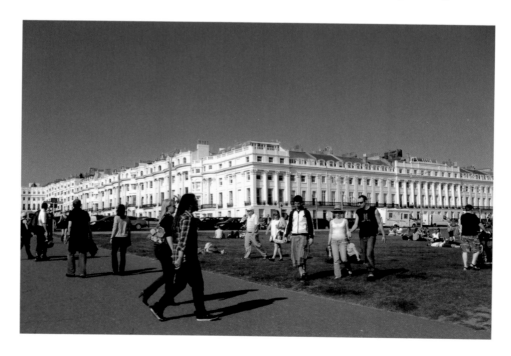

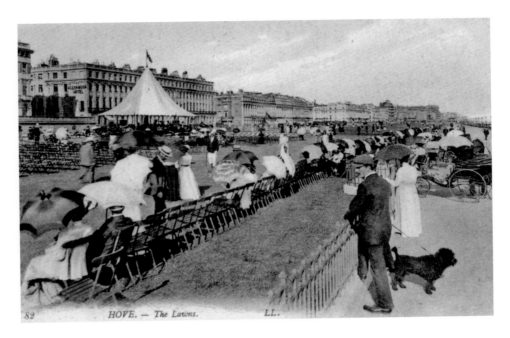

HOVE. — The Lawns.    LL.

## Brunswick Lawns

The summer scene was often enlivened by the strains of a military band playing under the shelter of a temporary bandstand. In the background is the Alexandra Hotel where Prince Metternich stayed in 1848 when it was a private house. In the 1990s the hotel was converted into flats. Note the kite like an exclamation mark in the recent view.

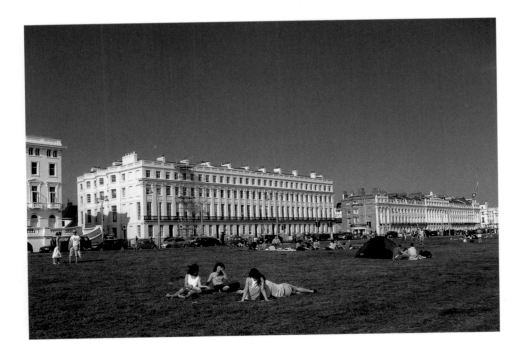

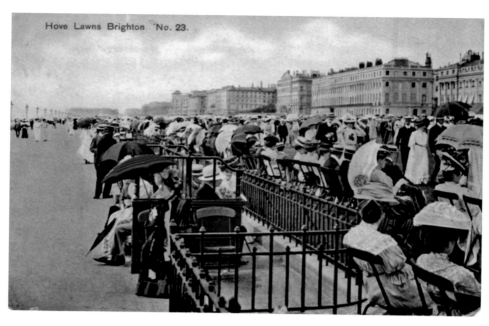

Hove Lawns Brighton `No. 23.

### Brunswick Lawns

The 1908 postcard provides a peep at some marvellous Edwardian hats. Note the gas lamps on the promenade. The position of the lamp-posts has altered but the dwarf wall, railing and seating positions remain unchanged. The modern view looks east towards Brighton where Embassy Court towers over Brunswick Terrace. It was once described as 'architectural bad manners.'

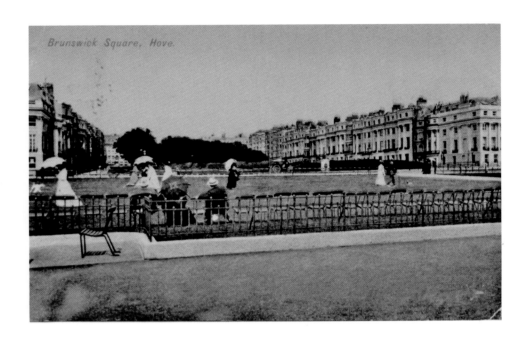

## Brunswick Square From the South

Brunswick Square was pictured in 1905 but the coloured frontages must surely be artistic licence because there was and still is a legal enforcement about uniformity of colour. However the proportions and elegance remain unchanged.

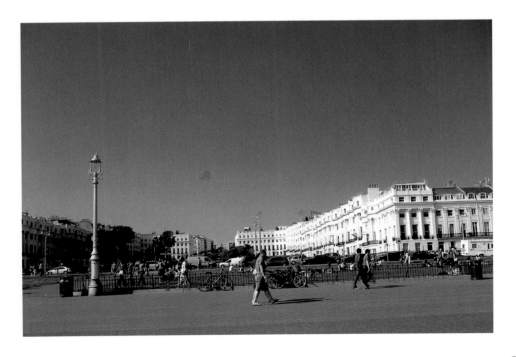

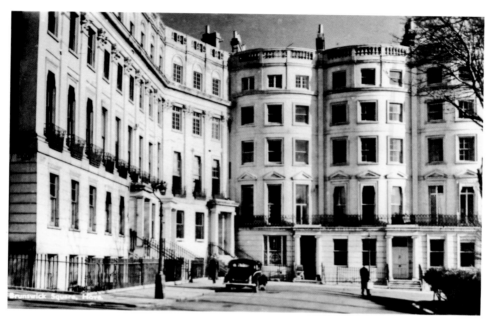

## Brunswick Square – North-east Corner

The two photographs of the north-east corner of Brunswick Square show the façades to be unaltered although the designated paint no longer contains lead. In 1851 number twenty-five housed a girls' school with four governesses and nineteen pupils. This was really against the rules because there were not supposed to be any commercial undertakings in the square.

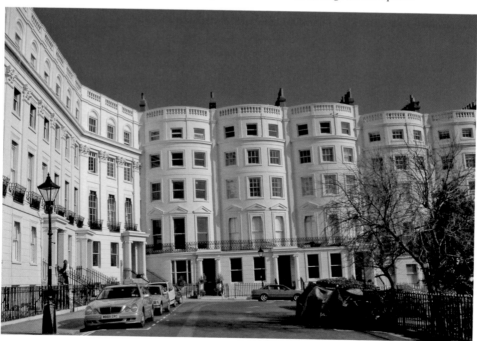

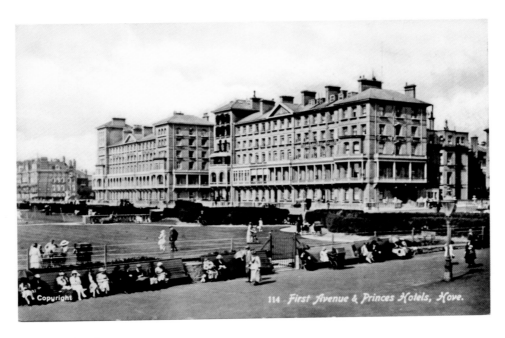

114 *First Avenue & Princes Hotels, Hove.*

Copyright

## Queen's Gardens

Sir James Knowles designed the two elegant terraces known as Queen's Gardens. Prince's Hotel occupied the western block and Disraeli was an early guest. First Avenue Hotel was in the eastern block and boasted three bath taps – hot, cold and seawater. Unfortunately this part was bomb damaged in 1941 and the whole terrace was demolished in the 1960s.

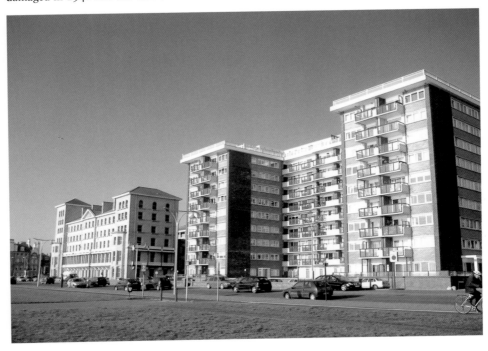

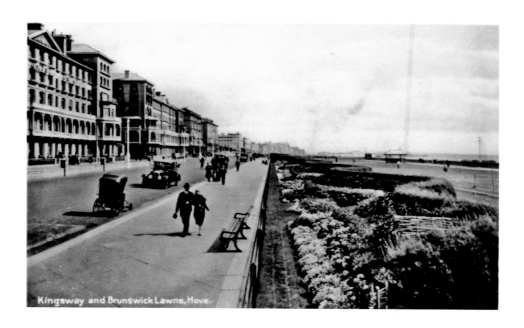

Kingsway and Brunswick Lawns, Hove.

## Kingsway

Sinuous hedging protected the flowers from wind damage and the gardens were still privately owned when the postcard view was taken. Hove Council did not take over their care until 1948. The recent photograph shows green sward and a cycle lane.

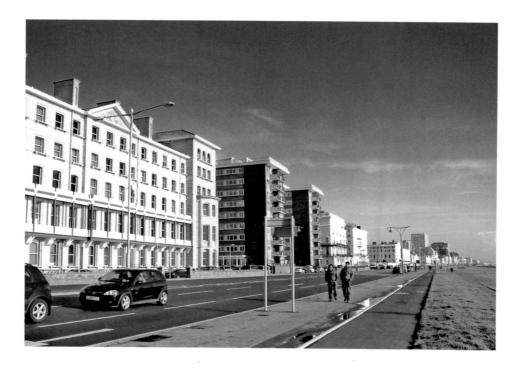

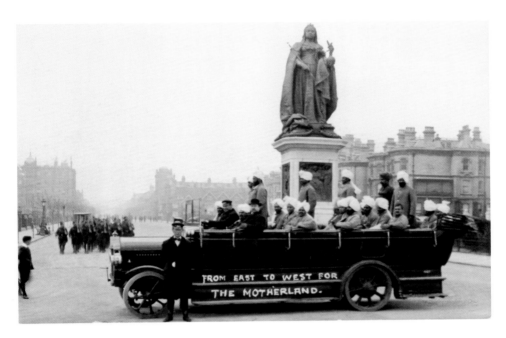

## Grand Avenue – Indian Soldiers

These Indian soldiers are enjoying an outing from the Indian Hospital in Brighton set up during the First World War. Their splendid charabanc halts before the statue of the Queen/Empress. The recent view reveals the dramatic changes in Grand Avenue where Coombe Lea (eighty-four flats) was the first and largest block to be built there.

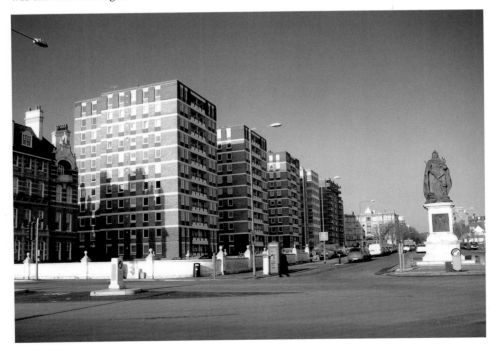

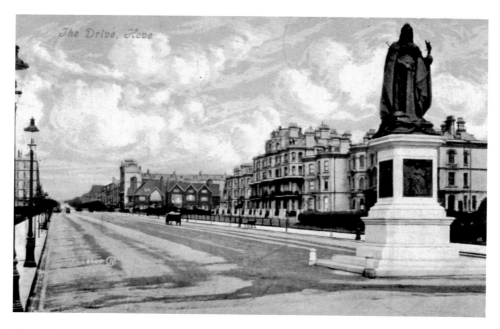

## Grand Avenue and Queen Victoria's Statue

Grand Avenue was the broadest road in Hove and considered to be a fitting place for Thomas Brock's majestic statue of Queen Victoria unveiled in 1901. In the second photograph King's House (once Prince's Hotel) is occupied by Brighton and Hove City Council. But from 1947 to the 1990s it was the Seeboard HQ.

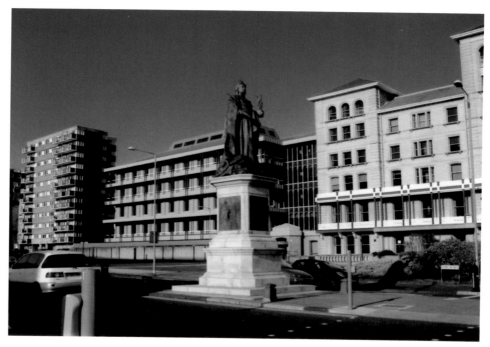

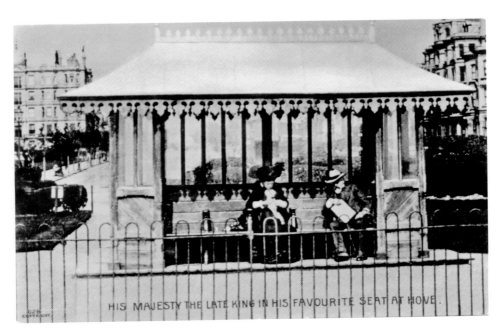

HIS MAJESTY THE LATE KING IN HIS FAVOURITE SEAT AT HOVE.

### King Edward VII's Favourite Seat

King Edward VII made four visits to his friends Arthur and Louise Sassoon at 8 King's Gardens, finding the sea air beneficial. His favourite seat was badly damaged in the 1987 gale but was faithfully restored by Hove Council.

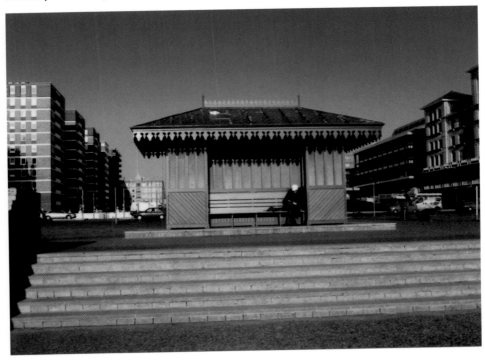

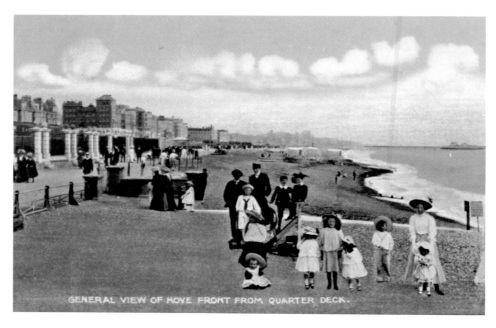

GENERAL VIEW OF HOVE FRONT FROM QUARTER DECK.

### View From the Quarter Deck

In Victorian times a caretaker was employed to look after the Quarter Deck for a wage of 7/6d a week. The Quarter Deck was so called because it jutted out from the rest of the promenade and it still provides a stunning viewpoint. In the modern photograph Flag Court and Courtenay Gate hide King's Gardens visible in the postcard.

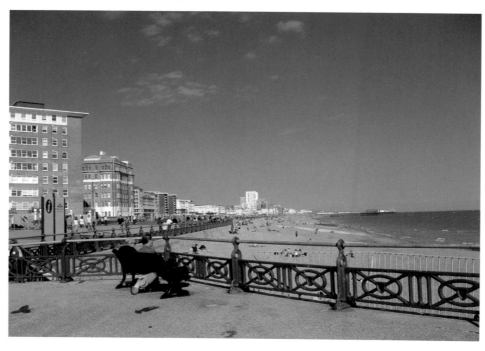

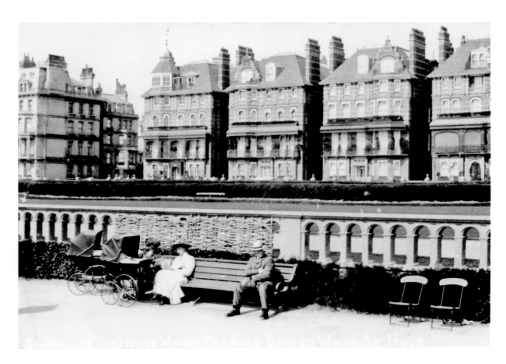

## King's Gardens From the Promenade

The stately edifices of King's Gardens were built in the 1890s. It seems astonishing they did not become listed buildings until 1992. Today the view from the promenade is partly obscured by beach huts – themselves an iconic Hove image.

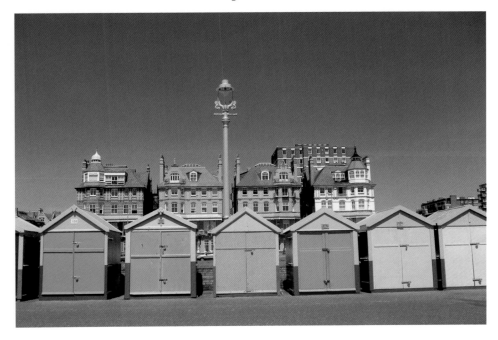

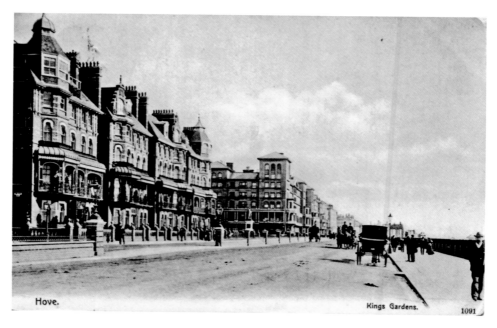

Hove.                                                    Kings Gardens.        1091

## King's Gardens From Kingsway

Mortimer Singer lived at 4 King's Gardens (the house on the left). In 1899 he presented the town with a solid silver mace decorated with amethysts, coral and enamel work because he was impressed by the excellent way in which Hove was governed.

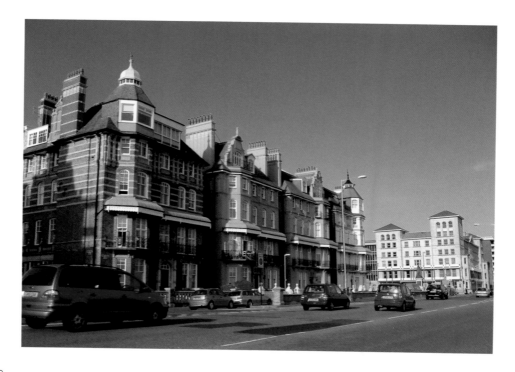

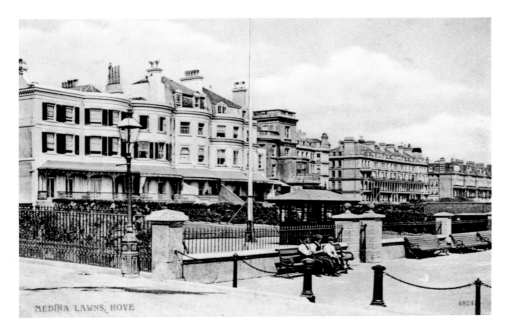

## Courtenay Terrace

The four original houses of Courtenay Terrace were built in the 1830s. In 1908 after a public enquiry Hove Council paid £2,363 in compensation to the owners for taking over part of their gardens in order to extend the promenade. In the second photograph the cycle path can be seen in the foreground.

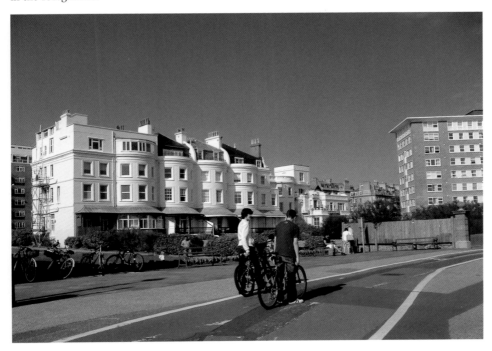

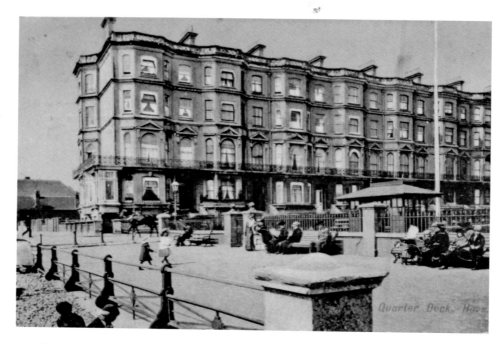

## Medina Esplanade

When Medina Terrace was built in the 1870s there were no tall buildings to obscure views towards Brighton. In the 1880s Kitty O'Shea and her husband Captain O'Shea occupied the corner house. When the captain was absent her famous lover Charles Stewart Parnell visited her there and was once obliged to make a hurried exit over the balcony.

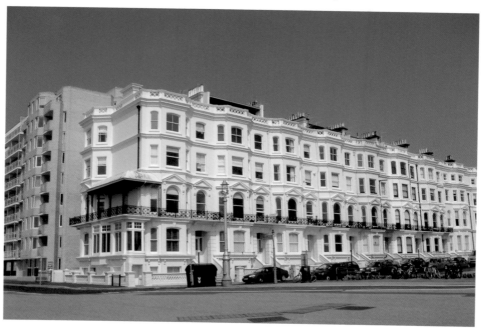

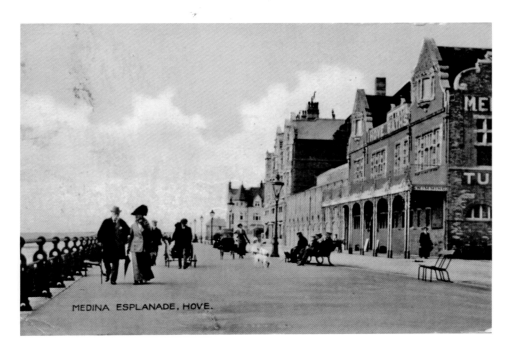

MEDINA ESPLANADE. HOVE.

## Medina Esplanade

Medina Baths opened in 1894 with separate pools for gentlemen and ladies and a laundry as well. You could hire towels and costumes. In 1979 work began on Bath Court, a £1 million development that now covers the site. In January 2009 the large crane in the background was being used to remove the flumes at the King Alfred.

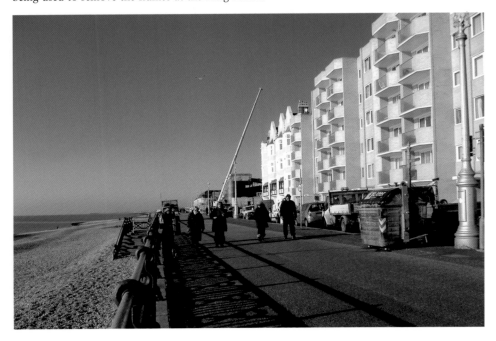

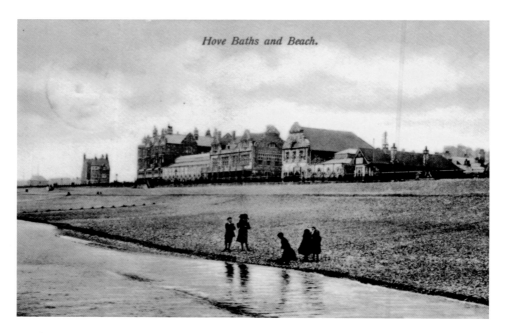

*Hove Baths and Beach.*

## Medina Baths From the Beach

In the postcard view Casa Amoena is the detached house on the left and Medina House is the gabled building on the right. Medina House belonged to the Medina Baths and it is the only part to survive. In 2009 plans to demolish it and replace it with flats were turned down. In the second view Marocco's café is seen to the right of Medina House.

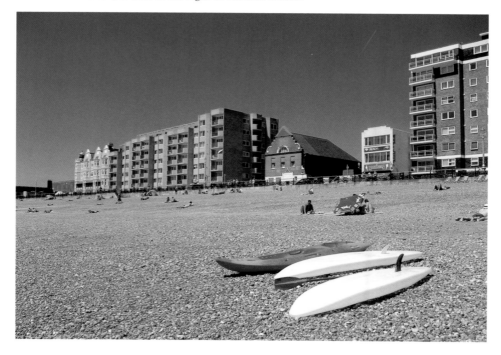

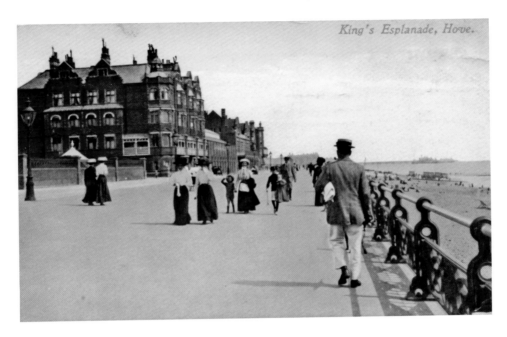

*King's Esplanade, Hove.*

## St Aubyn's Mansions

Lainson & Sons designed St Aubyn's Mansions in 1899. The handsome structure was later stuccoed, probably in the 1920s, to protect it from salt laden winds. Dame Clara Butt, the celebrated contralto singer, famous for her rendition of 'Abide with Me' and 'The Lost Chord' once occupied flat number 4.

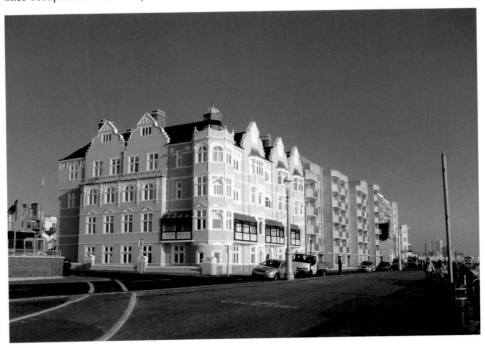

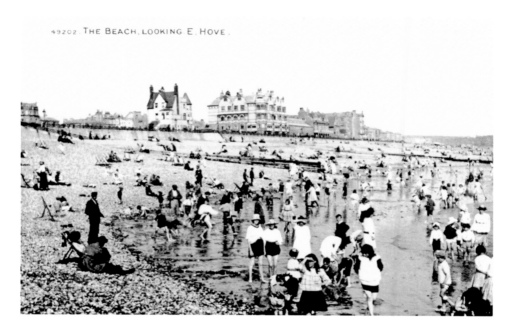

## Activity on the Beach

The gabled house in front of St Aubyn's Mansions is Casa Amoena (pleasant house) and the Dowager Duchess of Sutherland lived there from 1908 until her death in 1912. The house was demolished in 1938 when the new swimming baths (later called the King Alfred) were constructed. The second photograph was taken in June 2009 – the practice of having a lifeguard on the beach dates back to at least the 1890s.

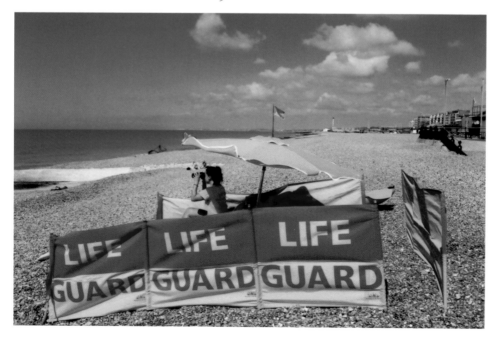

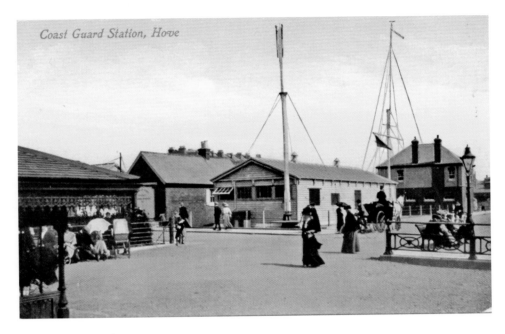

Coast Guard Station, Hove

## Coastguard Station, Hove

The Coastguard Station was established in 1823 because of Hove's reputation as a smuggling hotspot. It later formed part of HMS King Alfred. Hove Council purchased the site from the Admiralty in 1969 and forty years on it remains undeveloped despite many plans. The only point of reference between the two views is the railing.

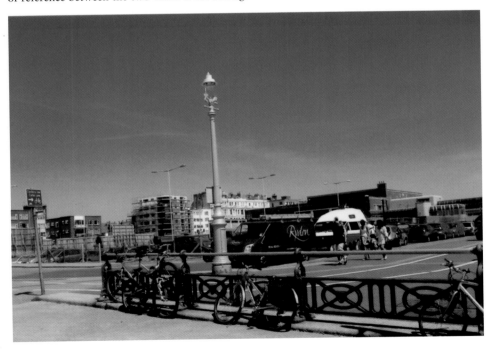

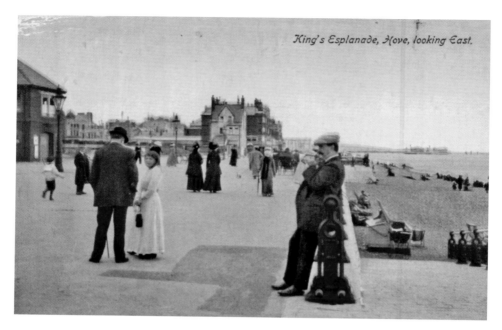

*King's Esplanade, Hove, looking East.*

### Slope to the Beach

This part of the esplanade was completed in 1897 and the slope was made so that the coastguards could move their boats to the beach. It also proved useful when horses were led into the sea to bathe. In the second view the new part of the King Alfred can be seen. These swimming pools opened in November 1982.

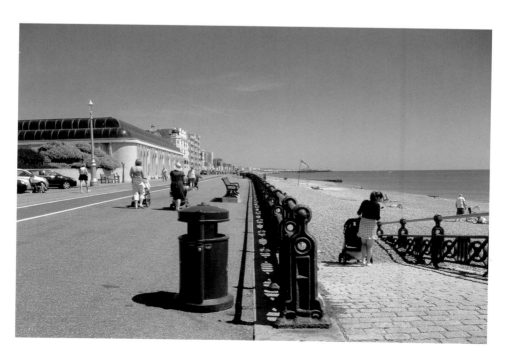

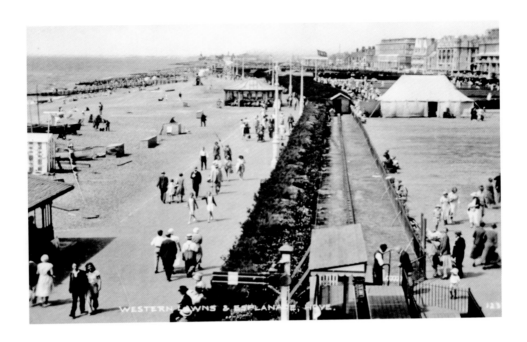

## Western Esplanade

On no. 1 Western Lawns a miniature railway operated in the summer from 1928 to 1939. The proceeds went to the Southern Railway Servants Orphanage. In recent years Zippo's Circus has visited in August. The modern photograph was taken in 2002.

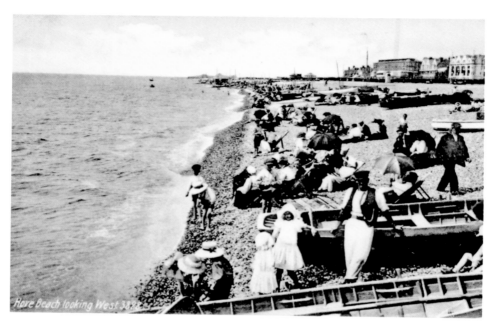

## Boats on the Beach

In 1912 there were thirty-nine rowing boats, three sailing boats and one motorboat available for hire at Hove. Boat building also once took place – the earliest named one being the lugger *Pearl* constructed in 1833. Today a few boats remain and nearby there is a small structure from where fresh fish may be purchased.

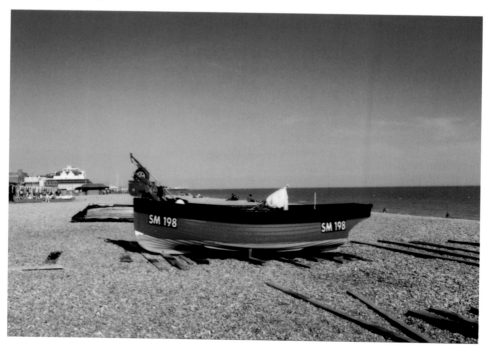

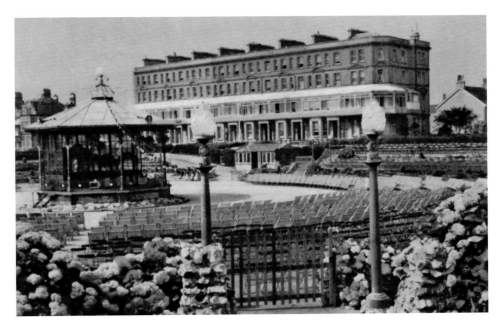

## Bandstand From the East

The bandstand dates from 1911 and during the first season the band of the 4th Dragoon Guards gave twenty-seven concerts. It is ironic this bandstand has gone while further along the road a fortune is being lavished on restoring the Brighton one. Part of Walsingham Terrace was bomb damaged in 1943 and was replaced by Dorset Court in the 1950s.

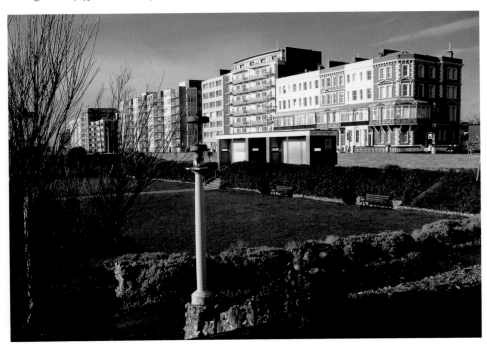

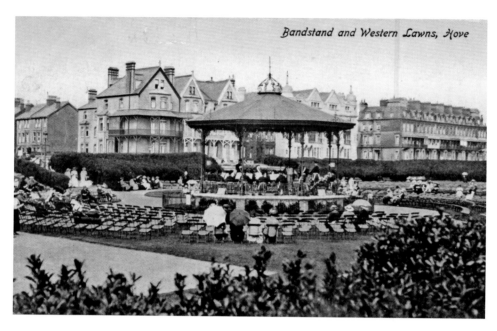

*Bandstand and Western Lawns, Hove*

### Bandstand From the West

This earlier view of the bandstand shows it without the glazed screen that later proved to be such a magnet for vandalism. The bandstand was demolished in 1965. The gabled Girton House was once a posh girls' school where lisle stockings were obligatory, winter and summer.

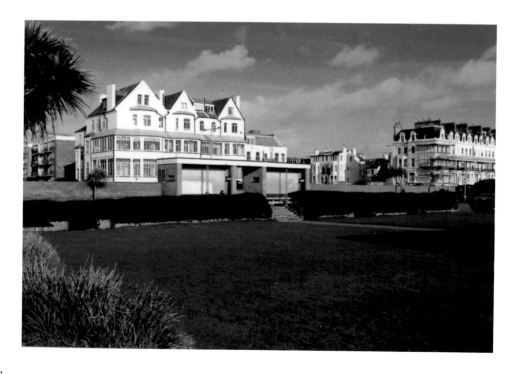

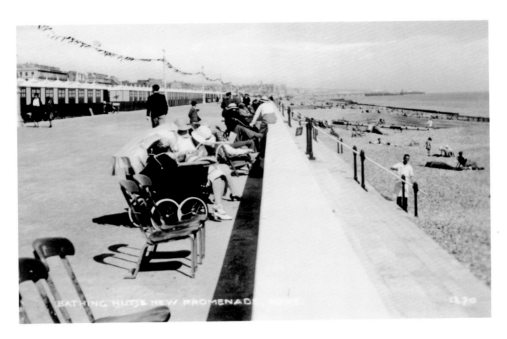

## Western Esplanade

The new sea wall was constructed in the 1930s after severe storm damage and Hove Council needed to borrow £29,000 for the project. Today the shingle has backed up to such an extent that only the top two or three steps are visible. Note the beach huts with the little pinnacles. The second photograph was taken in January 2009 after a heavy downpour.

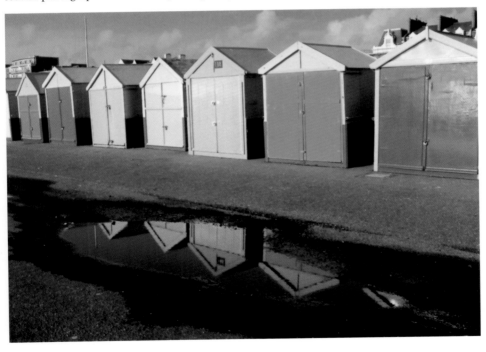

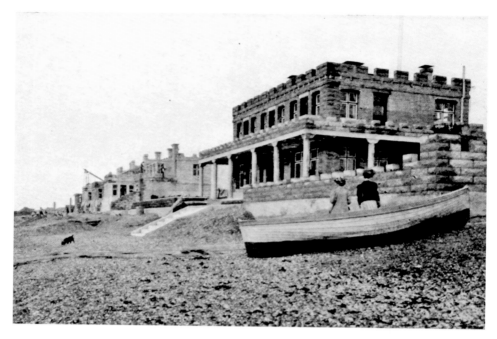

## Seaside Villas

These unique villas, literally built on the beach, have long been a haven for celebrities. Local people call them Millionaires' Row. Although the exteriors are now sparkling white, during the Second World War they were covered with dark paint for camouflage. The villas were built with 12-inch thick concrete walls while the foundations went down 20 feet.

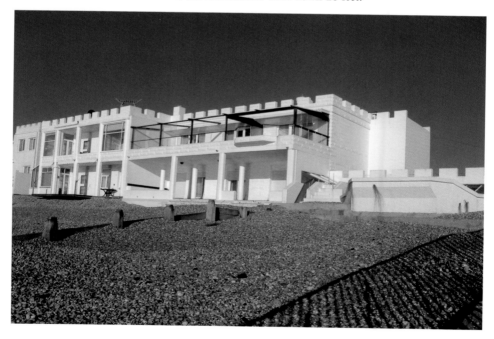

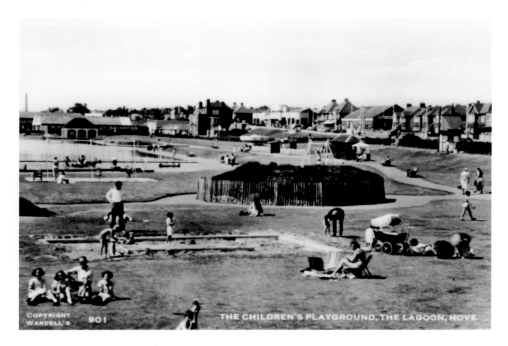

## Hove Lagoon – Playgrounds

There used to be a tidal pond with mud flats where Hove Lagoon was established in 1930. The modern view shows the recently established skateboard park on the left with the paddling pool on the right. The café was revamped as a vegan café for Heather Mills, and opened in July 2009.

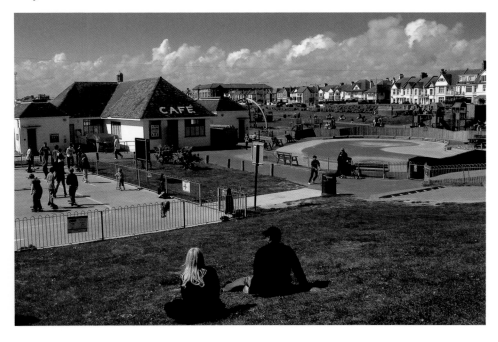

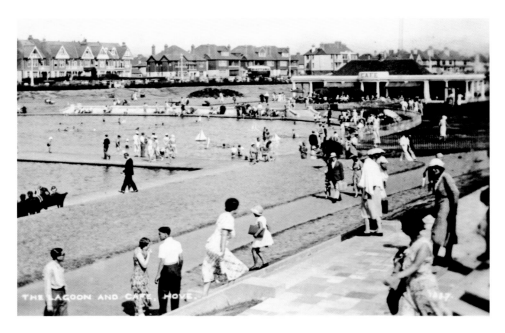

## Hove Lagoon – Watersports

The first view dates from 1937 when many people were enjoying the Lagoon but during the war it was part of the restricted zone. Hove Lagoon Watersports has been based here since the 1980s and their new clubhouse opened in 1994.

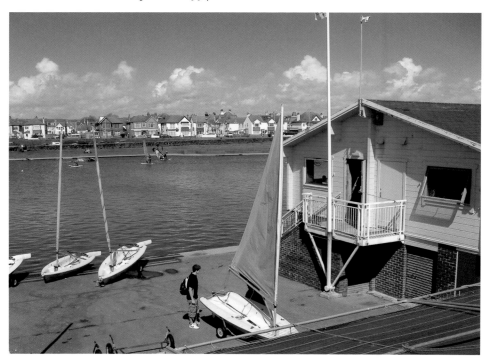

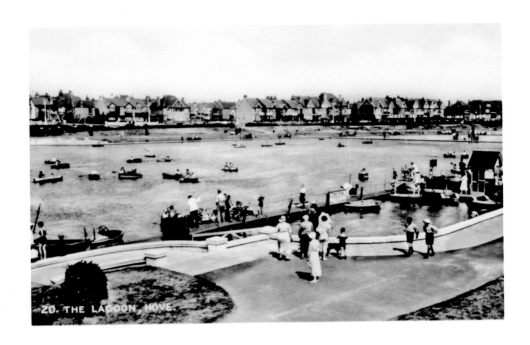

## Hove Lagoon – on the Water

The Lagoon cost £11,700 to construct. As well as the boats and occupants shown here the Lagoon was also the venue for model boats. In the Second World War the Lagoon served a more serious purpose when watertight tanks were tested at night in the run up to D-Day. The recent photograph shows the variety of water sports.

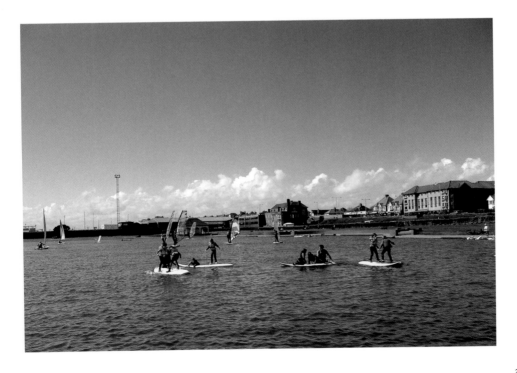

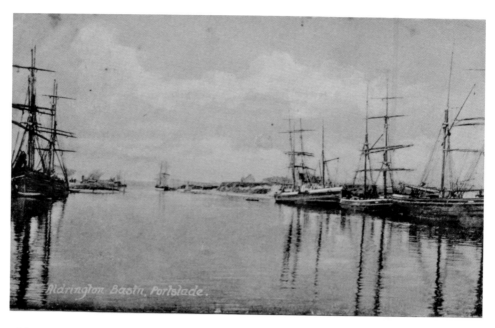

## Aldrington Basin

Aldrington Basin is the easternmost part of Shoreham Harbour and this postcard shows how it looked in the days when vessels were powered by sail. The recent photograph was taken in April 2009 with activity near the fishing boats. A small shop on the dock sells fresh fish.

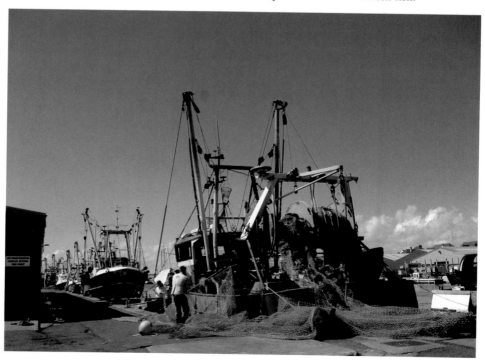

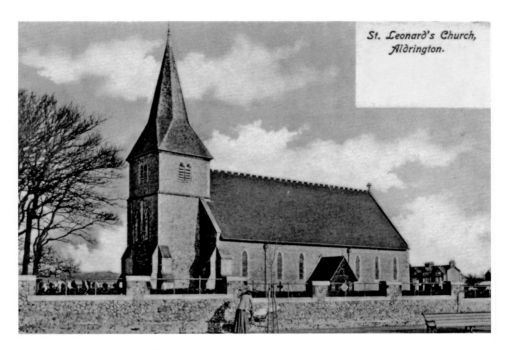

St. Leonard's Church, Aldrington.

## St Leonard's Church, Aldrington

In 1871 when St Leonard's Church was still a ruin, the fortunate incumbent earned £300 a year for doing nothing. It was a Victorian scandal. The church was rebuilt in the 1870s as seen in the postcard view. But large extensions were added in the 1930s. In the second view the churchyard hosted a carpet of wild flowers in June 2009.

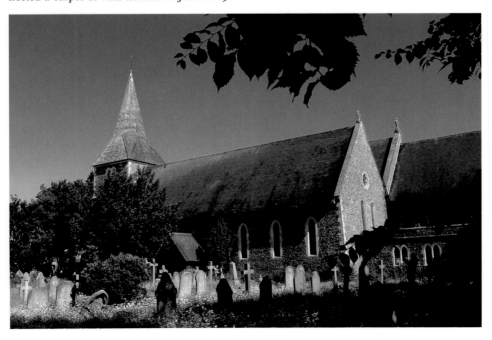

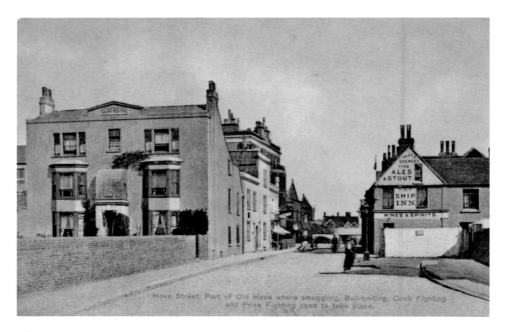

Hove Street. Part of Old Hove where smuggling, Bull-baiting, Cock Fighting and Prize Fighting used to take place.

## Hove Street From the South

The old Ship Inn was pulled down when Hove Street was widened. In 1915 it was rebuilt further back. Cliff House on the left was demolished in 1936 and Viceroy Lodge was built on the site. Lady Olive Douglas, estranged wife of Lord Alfred Douglas of Oscar Wilde fame, once lived here.

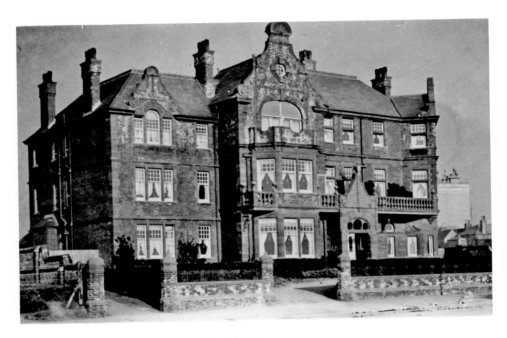

## Langton House and Princes Marine Hotel

Hove College occupied Cliff House until 1935, then moved to Langton House where it remained until it closed in 1980. The building was being converted into a nursing home when fire broke out in 1981 and it was demolished in 1983. A new but unsuccessful nursing home arose on the site and in 1989 the Princes Marine Hotel opened there.

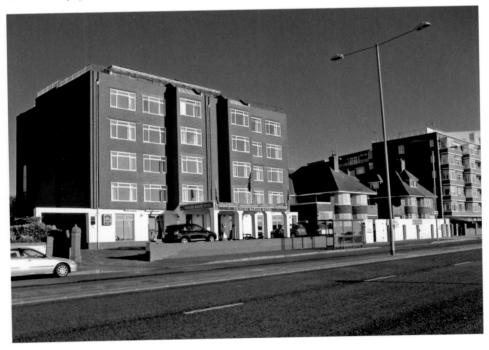

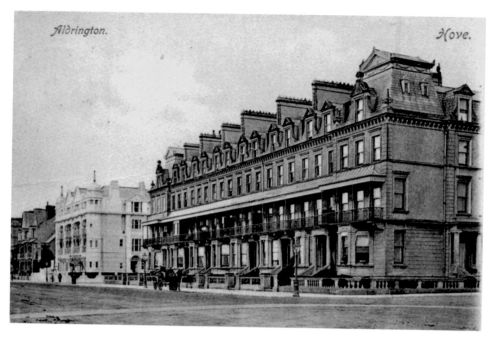

### Kingsway Looking West

The postcard correctly identifies this handsome terrace as being in Aldrington, and Hove and Aldrington amalgamated in 1893. The view remains little changed today apart from the empty site where the late lamented Sackville Hotel used to stand.

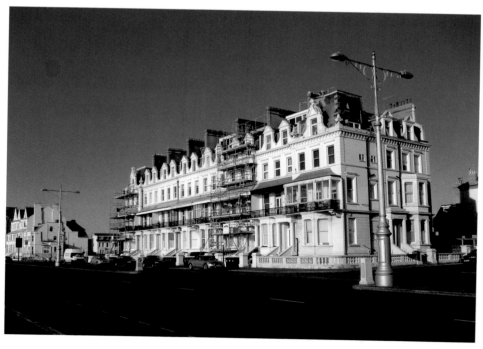

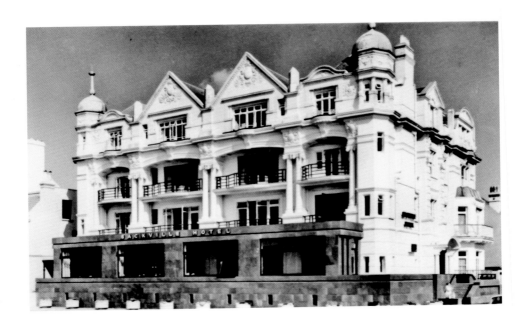

## Sackville Hotel in its Heyday

This structure started out in 1904 as four residences called The Lawns, costing around £8,000 a house. Each one was heated throughout, had eight bedrooms, a library, electric lift and electric Turkish bath. But by the 1920s they had become the Sackville Hotel. The modern photograph was taken in 2002 when the hotel was still open.

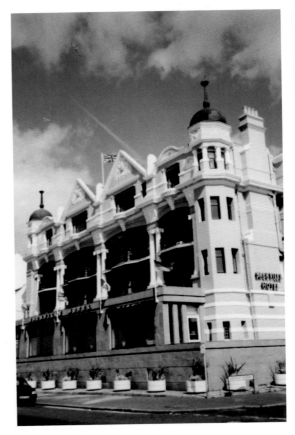

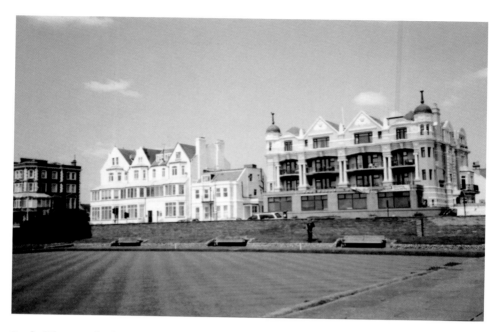

## Sackville Hotel After its Collapse

The top photograph was taken in 2005, the year the hotel closed. Some £5 million was to be spent on a complete refurbishment but in May 2006 part of it collapsed causing chaos on the Kingsway and the whole building had to be demolished. The second photograph was taken from 'a' bowling green.

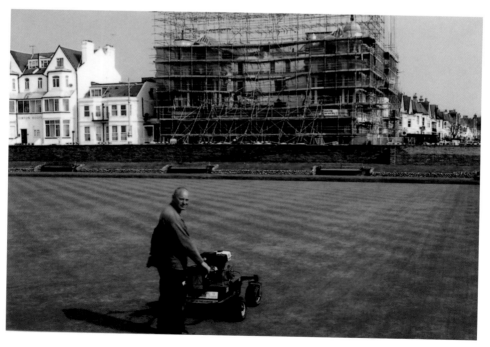

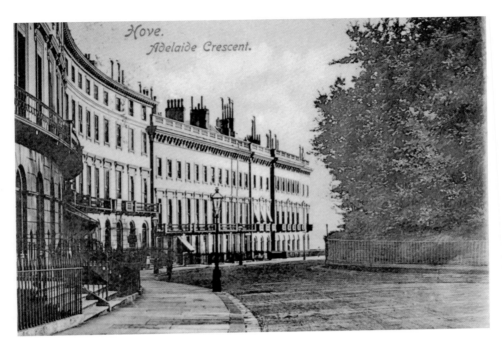

## Adelaide Crescent, Hove

Although the original plans for Adelaide Crescent in the 1830s envisaged the houses arranged in a conventional crescent, by the 1860s the development had been completed as two wings opening into Palmeira Square. Note the new lamppost in the modern view that has been closely modelled on the old style visible in the first view.

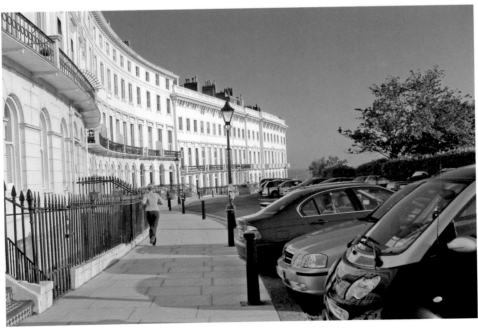

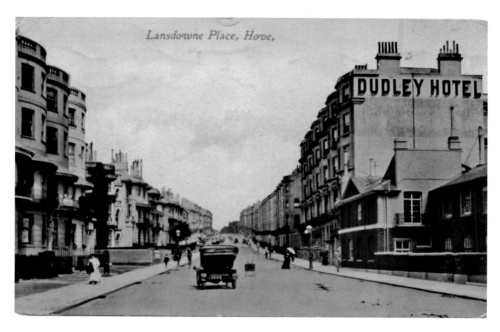

*Lansdowne Place, Hove,*

## Landsdowne Place, Hove

The Dudley began as a modest boarding house in the 1850s but spread to all six houses of Lansdowne Mansions. The hotel continued to function in the Second World War and in 1945 the Mayor of Hove gave a farewell dinner for the officers from HMS *King Alfred*. The chef produced a fine ship carved in ice. Local people referred to the hotel as Deadly Dudley or Fuddy Dudley. Not surprisingly it has been renamed and is now Lansdowne Place Hotel.

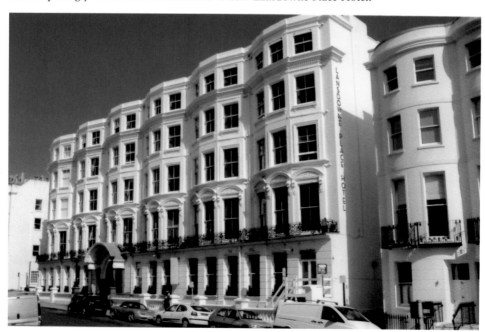

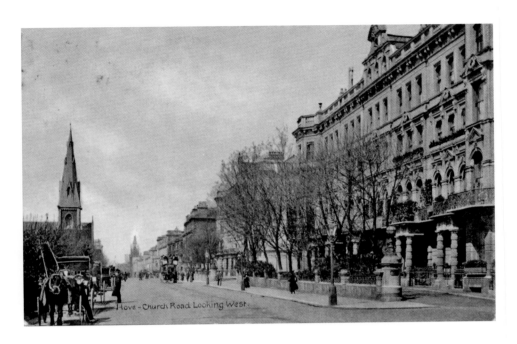

Hove - Church Road Looking West.

## Palmeira Mansions

Palmeira Mansions were built to
luxurious standards in the 1880s.
Amongst the fittings were carved
marble chimney pieces, tiled hearths,
Venetian blinds, a billiard room
and a wine cellar. Today with their
painted façades they have never
looked better. The handsome lamps
were recreated from the original
design in the 1990s. The modern
photograph was taken in 2002.

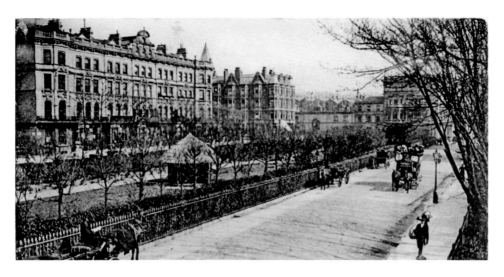

## Palmeira Mansions and the Floral Clock

In 1905 the gardens shown here were still private and residents in adjacent houses paid a special garden rate. The railings came down for salvage in the Second World War. Note the horse bus – there were thirty-seven of them at Hove in 1902. The second view taken in 2002 looks towards Palmeira Mansions across the Floral Clock installed to celebrate Queen Elizabeth II's coronation.

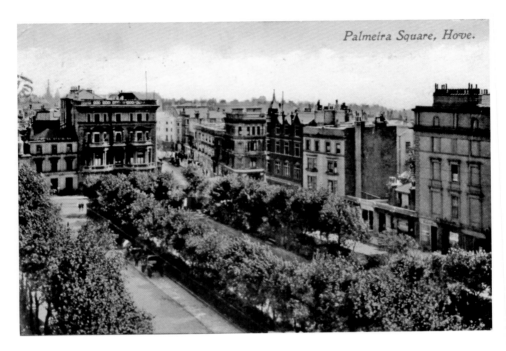

*Palmeira Square, Hove.*

## The View From Palmeira Mansions

The grey building (65/67 Western Road) was destroyed by bombs in 1941. Note the hackney carriage stand. The cobblestones were retained as an acknowledgement to this when the recent improvements were carried out. The second photograph dates from 2002.

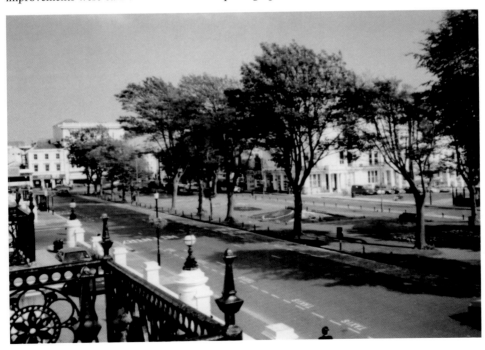

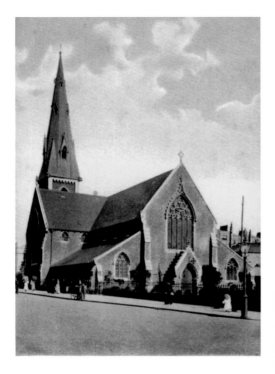

## St John's Church

When the Bishop of Chichester laid the foundation stone of St John's Church in 1852 he emphasised the fact that Isaac Lyon Goldsmid (a Jew) had donated the site. The church was consecrated in 1854 and the tower and spire were added in the 1870s. Once so popular there were queues to get in, by the 1990s it was underused and most of the space was converted to community use.

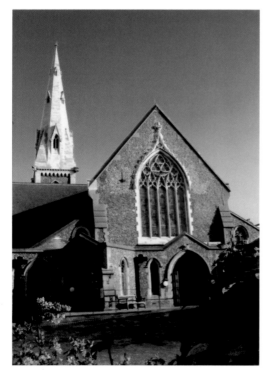

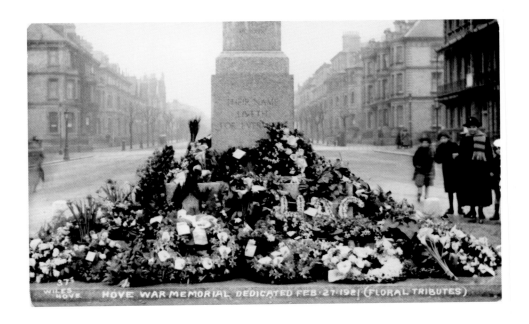

## Hove War Memorial Looking North

Over 600 Hove men were killed in the First World War. Sir Edwin Lutyens designed the war memorial with its bronze St George on a pedestal. One of the floral tributes was from Brighton & Hove Albion and was inscribed 'Their last and finest goal.' Apart from the blocks of flats in the distance, the view today is little changed.

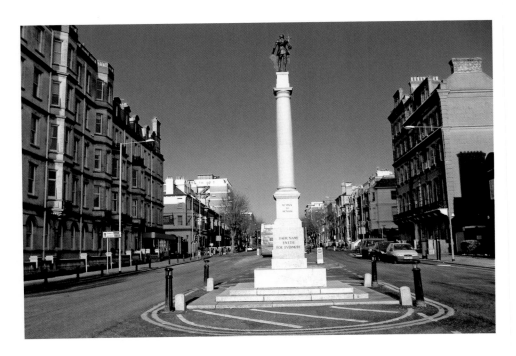

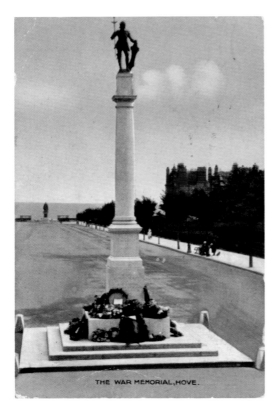

THE WAR MEMORIAL, HOVE.

### Hove War Memorial Looking South

These two views chart the enormous changes that have taken place in Grand Avenue. There were spacious detached houses in their own grounds on the west side. During the Second World War Grand Avenue was behind barbed wire since the Admiralty had requisitioned most of the properties. Today there are huge blocks of flats.

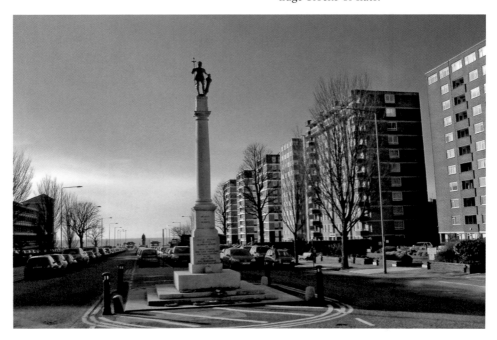

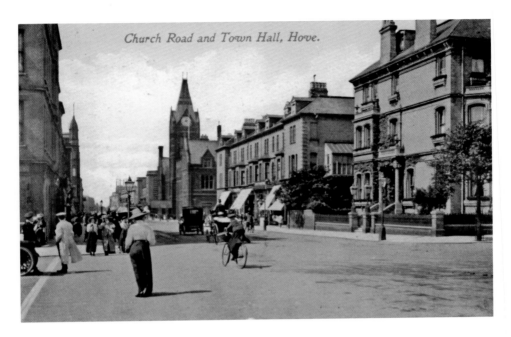

*Church Road and Town Hall, Hove.*

## Church Road Looking West

The large house on the right built in 1877 was no. 2 The Drive and boasted two imposing lamps on gate piers. The recent photograph shows how it has been remodelled for commercial purposes and the ground floor is now home to Café Nero while English classes are advertised above – English Language Schools being one of Hove's cottage industries.

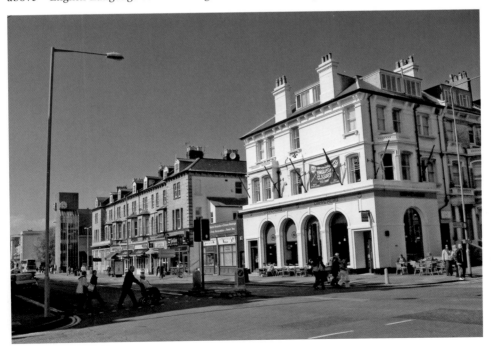

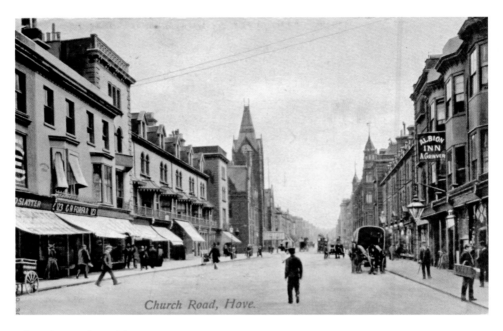

Church Road, Hove.

### Church Road Looking East

Forfar's shop on the left in Church Road sold bread and cakes and is still in business in 2009. George Forfar took over the established bakery in the 1880s. In 1902 Forfar's offered fifteen different sorts of loaves. Mr Grinyer became landlord of the Albion in the 1880s and retained the licence for twenty-three years. He was a keen yachtsman.

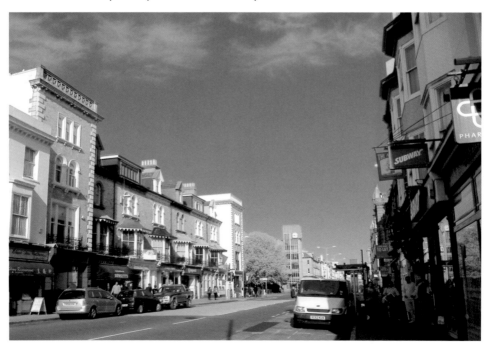

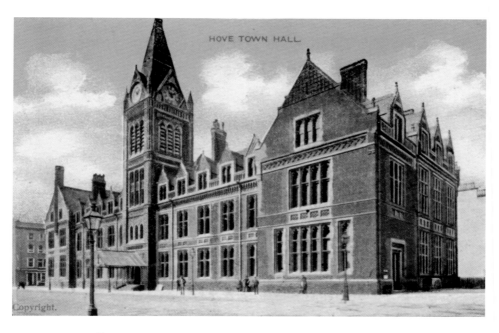

HOVE TOWN HALL

## Hove Town Hall

The esteemed Victorian architect Alfred Waterhouse designed Hove Town Hall. It opened in 1882 but was devastated by fire in 1966 and councillors decided upon demolition. John Wells-Thorpe designed the new Town Hall and it opened in 1974. Since amalgamation with Brighton, the building has lost the plot somewhat and is known as the Hove Centre.

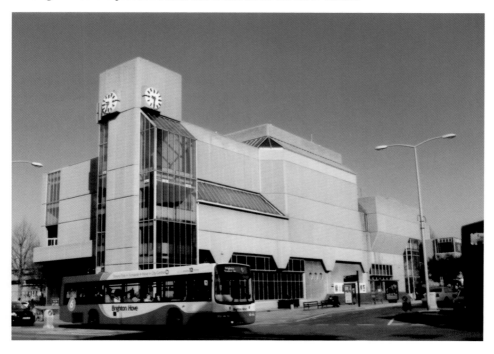

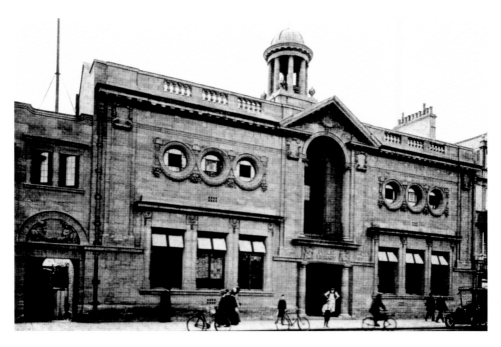

## Hove Library

Andrew Carnegie donated £10,000 to build Hove Library and it opened on 8 July 1908. In recent times a plan to move the library resulted in public outrage with yellow protest leaflets in many windows and instead the building was renovated to modern requirements and Hove Library celebrated its centenary still there. The cupola was removed in 1967.

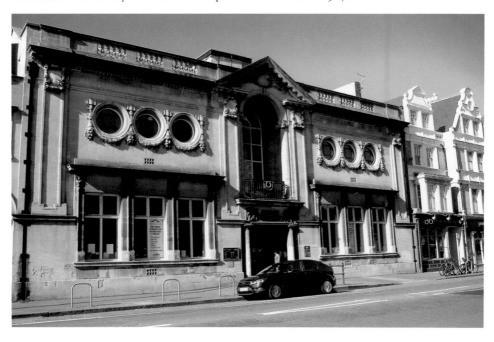

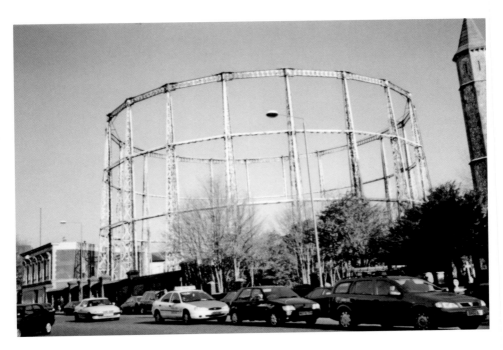

## Church Road and Gasholder

The gasholder pictured here in 2002 was constructed in 1877 under the personal supervision of J. B. Paddon and continued in use until the 1990s. It was fronted by a handsome flint and red brick wall adjoined by the gas showroom seen on the left. All were swept away to make way for Tesco's.

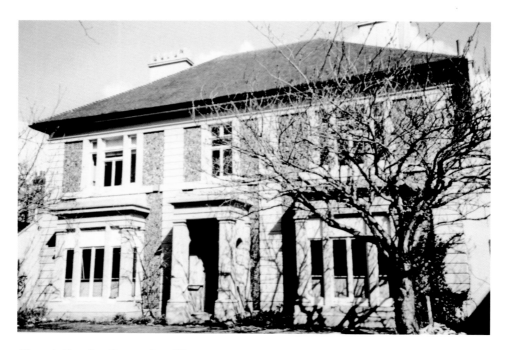

## Church Road – Gasworks Villa

This substantial villa was home to the civil engineer in charge of the gasworks. In 1881 Joseph B. Paddon, his wife, two sons and four servants lived here. The house was photographed in April 1999 before the cherry trees blossomed. The café part of Tesco's now covers the site.

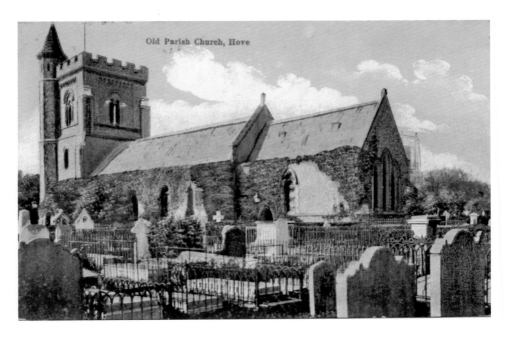

## St Andrew's Church

St Andrew's Church assumed its present shape in the 1830s. The earlier view dates from 1906 when there was an extensive churchyard to the north, most of it now covered by a school playing field. Tomb railings have also gone. In the second view the grey rounded tombstone of Sir George Everest can be glimpsed to the left. Mount Everest was named after him.

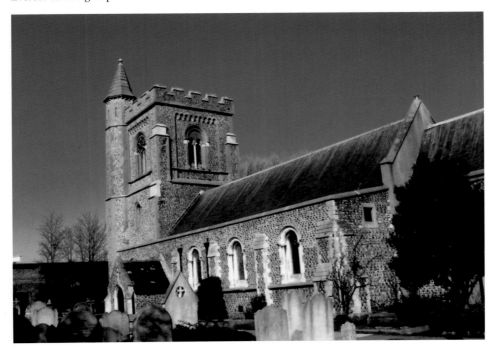

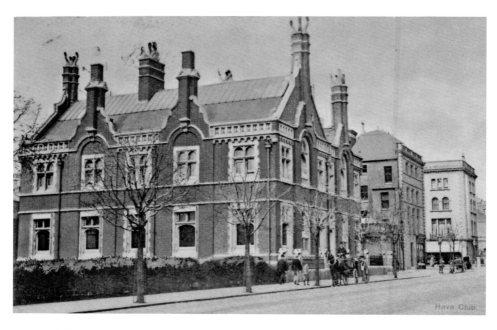

## Hove Club

Samuel Denman designed this stately building for the Hove Club and they moved into it in 1890. In 1897 there were 289 gentlemen members, including twenty-three clergymen, fifteen colonels and 10 major generals. Amongst its titled members were Baron de Worms, Sir Julian Goldsmid and Sir Edward Sassoon. Hove Club remains in residence sharing the premises with a casino.

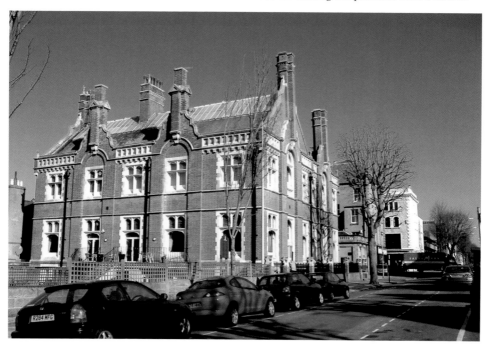

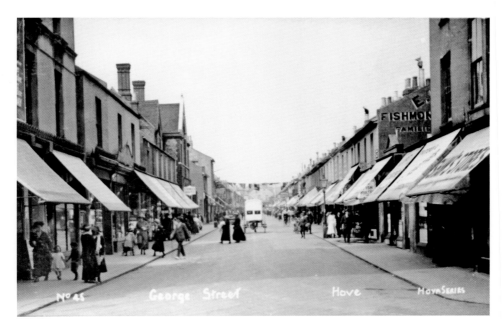

## George Street Looking North

The tall chimney and gable on the left belong to the George Street National Schools and beyond it is the Royal George Inn, both since demolished. In 1872 there were ninety-eight houses in George Street and in 1878 there were an astonishing 632 inhabitants. Today George Street has some trees and hanging baskets to give it a greener aspect.

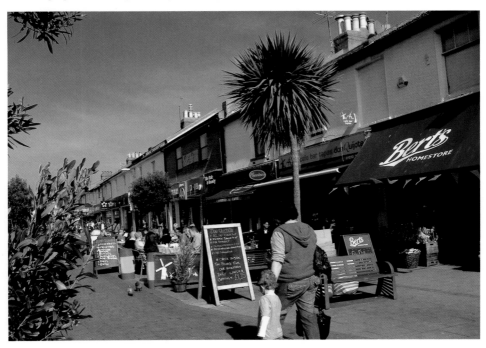

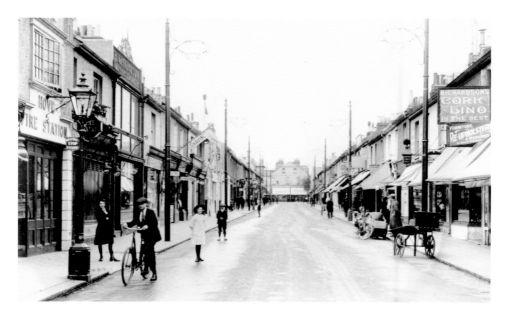

## George Street and the Fire Station

In this view of George Street in 1914 the poles erected for the experimental trolley bus are visible. On the left at no. 85 is Hove Fire Station. It remained there until 1926 despite the difficulties of turning the fire engine in such a confined space. Today Georgie's café occupies the premises and the Hove coat-of-arms is still there.

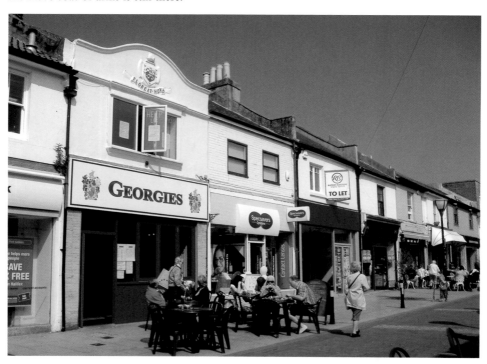

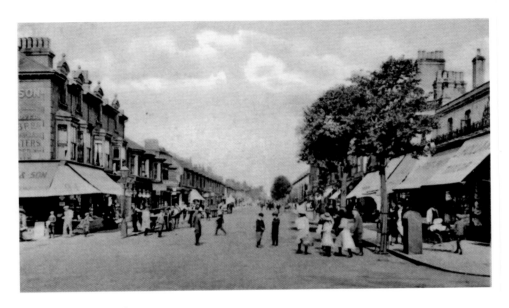

## Blatchington Road – East Corner

The postcard of Blatchington Road dates from 1911. There were once 22 trees along the north side but they were felled in 1925 because they were regarded as a traffic hazard. On the right are three shops built in 1898 and demolished in the 1930s to make way for Woolworths. The latter closed in January 2009.

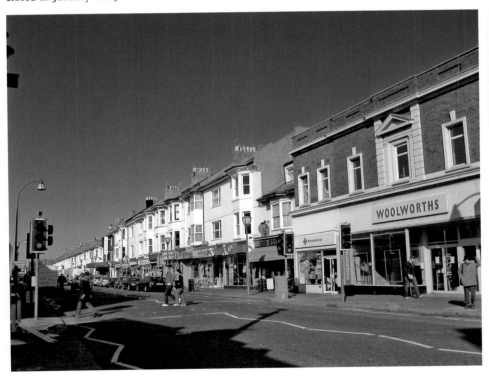

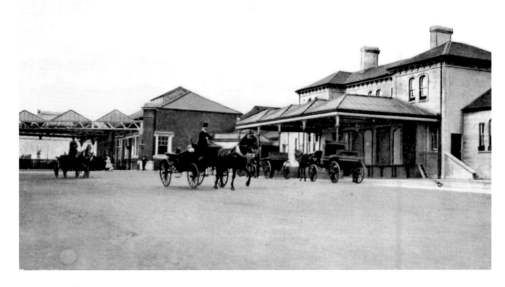

## Hove Station

The structure on the right was built in 1865 and called Cliftonville Station and later West Brighton. The building on the left, still in use as Hove Station, was erected in 1905. Although the canopy on the right has been removed, the one on the left survives with its decorative ironwork including shields bearing the LBSCR motif.

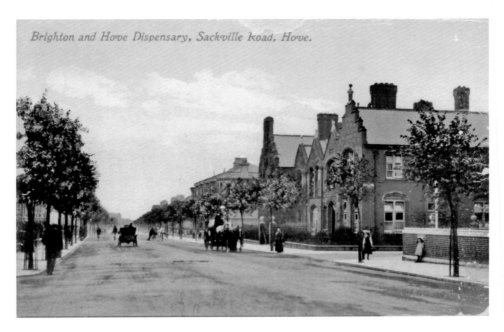

*Brighton and Hove Dispensary, Sackville Road, Hove.*

## Sackville Road and Hove Hospital

Sackville Road was an ancient route known as Hove Drove. On the right is Hove Hospital (formerly Brighton and Hove Dispensary). It opened in 1888. There were many generous donations and in 1893 the Duke and Duchess of York endowed the Princess May cot. The hospital closed on Christmas Eve 1997 and has since been converted into flats.

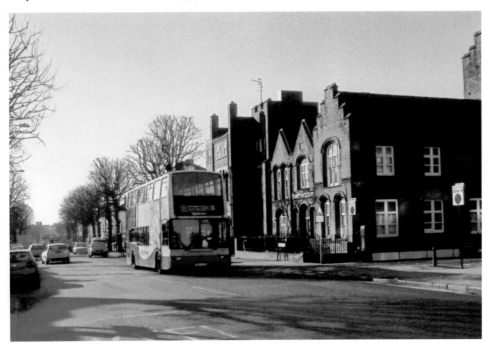

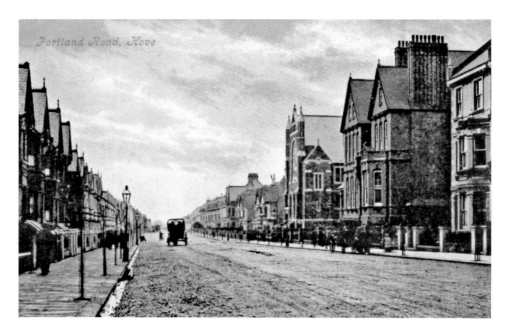

## Portland Road

The eastern end of Portland Road is dominated by two important buildings; the Convalescent Police Seaside Home built in 1893 and Hove Methodist Church dating from 1896. The police home was the brainchild of Catherine Gurney who heard about a policeman in an ordinary convalescent home who found in the next bed a criminal he had once arrested.

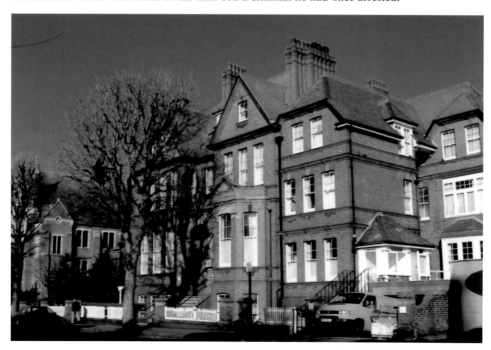

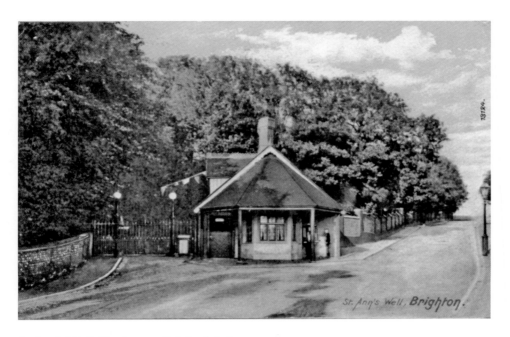

## St Ann's Well Gardens – Original Entrance

This postcard of the entrance to St Ann's Well Gardens dates from 1905 when the gardens were still in private ownership. There used to be a thatched cottage there but it was replaced in the 1880s by this lodge and a second storey was added later on. The lodge survived until the 1960s. In the background of the recent view Furze Hill House is aptly named because the chalybeate used to flow from a low furze-covered hill.

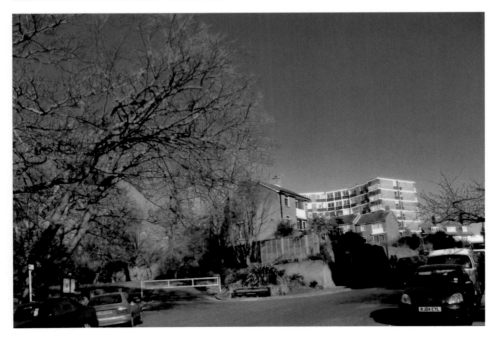

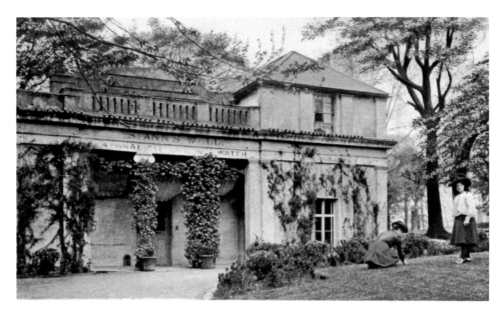

## St Ann's Well Gardens and the Pump House

The pump house at St Ann's Well Gardens was built around the celebrated chalybeate spring and this charming view dates from 1904. The water, although recognised as beneficial, was cloudy and its iron content gave it a characteristic smell. The pump house was demolished in the 1930s. The second view looks across the crocuses to where the pump house once stood.

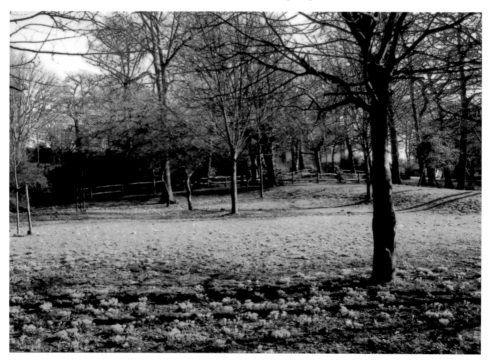

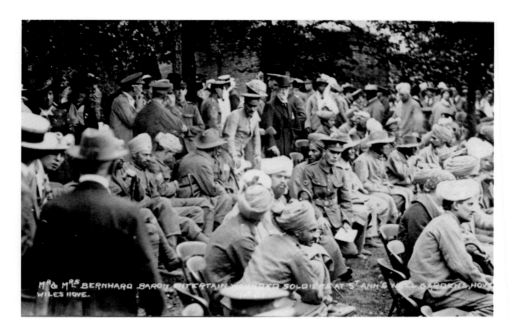

## St Ann's Well Gardens – Entertainments

Bernard Baron made his fortune from the Black Cat cigarette company and during the First World War he hired St Ann's Well Gardens and entertained wounded soldiers. He can be seen at the centre sporting a bowler hat and wing collar. The second photograph was taken on 23 May 2009 with the Brighton School of Samba performing at the Spring Festival.

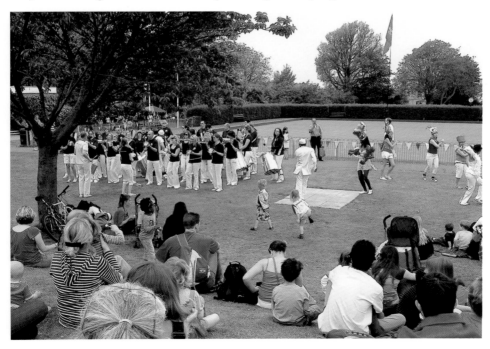

## Holland Road – From Gym to Synagogue

In 1883 a gymnasium was built in Holland Road for Charles Moss. His successor was Percy Stuart Rolt and he was the proprietor when this postcard was made. In 1928 Rolt sold the property for £5,500 to Hove Hebrew Congregation. The building was converted into a synagogue and consecrated on 23 February 1930.

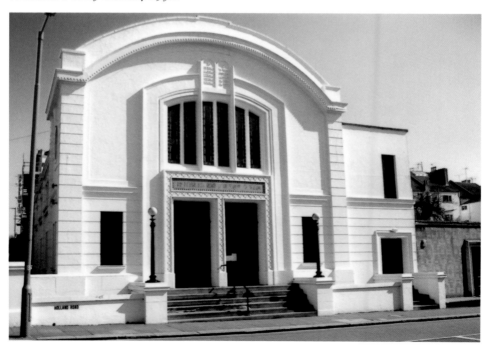

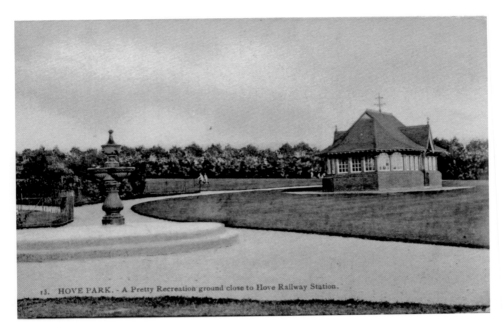

13.   HOVE PARK. - A Pretty Recreation ground close to Hove Railway Station.

## Hove Recreation Ground and Pavilion

Hove Recreation Ground is the oldest public green space in Hove. It opened in 1891 and the pavilion was part of the original layout. Alderman J. W. Howlett donated the water fountain. Howlett was known as the 'Father of Hove' and during the 1870s battled successfully against Brighton taking over Hove. The fountain has long gone and the sports pavilion looks unloved to say the least.

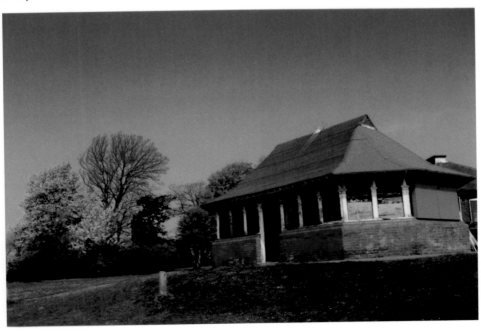

## Hove Recreation Ground and the Dell
The dell was also part of the original design of Hove Recreation Ground and was intended as a haven on windy days. Two sloping paths led into it. It has since been levelled out. The only evidence as to the dell's existence is the circular path around the site.

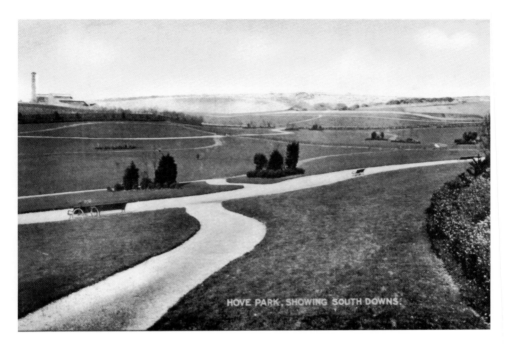

## Hove Park

Although this postcard of Hove Park dates from a few years after it opened in 1906, the view is still bleak. Many trees were planted but two-thirds were destroyed by the 1987 gale. However the opportunity was then taken to re-site the children's playground to a sunnier position on the east side of the park.

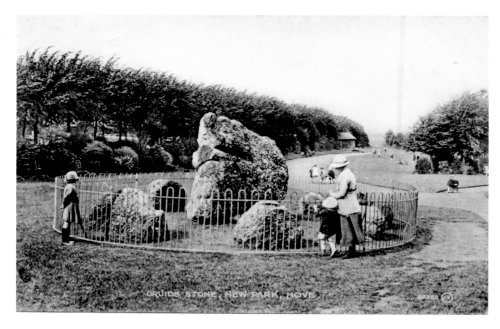

## Hove Park and the Goldstone

Farmer Rigden ordered the Goldstone, once the outlier of a stone circle, to be buried in 1834. This was because parties of sightseers used to travel from Brighton to see the supposedly 'Druid' relic, trampling his crops on the way. It was unearthed in 1900 and set up in Hove Park in 1906 where it can be seen today.

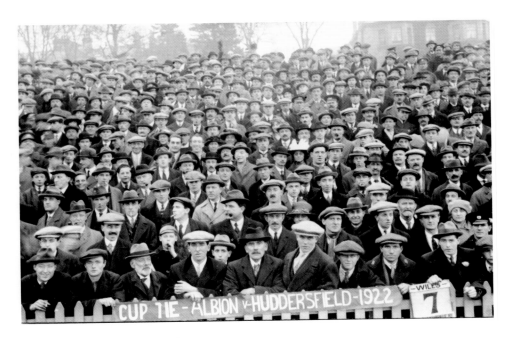

## Goldstone Football Ground

There was a record gate of 22,241 spectators for this cup-tie match. The sale of the Goldstone Ground in the 1990s was a bitter blow to Brighton & Hove Albion fans and some cannot bear to visit the stores built on the site. However, in 2009 a new Albion football ground is under construction at Falmer.

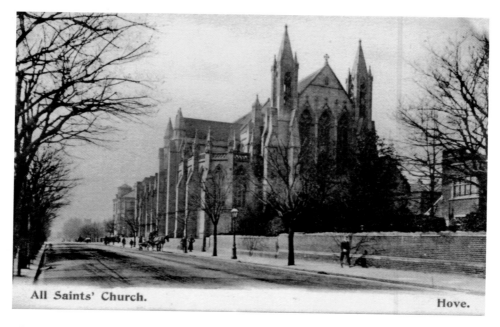

All Saints' Church.                                                    Hove.

## All Saints' Church

J. L. Pearson, the architect of Truro Cathedral, also designed All Saints' Church. This magnificent building was completed by 1901 but the cost of maintaining its fabric is such a heavy burden that its future is by no means secure. The choice of Sussex sandstone for the exterior was not a sensible one because it weathers badly in seaside air.

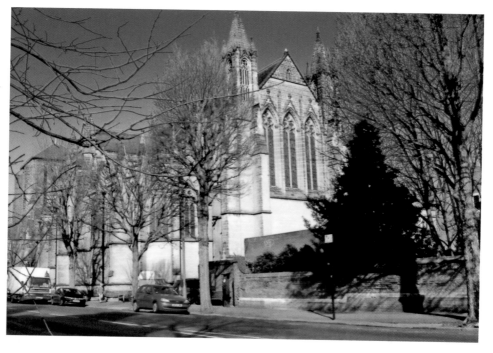

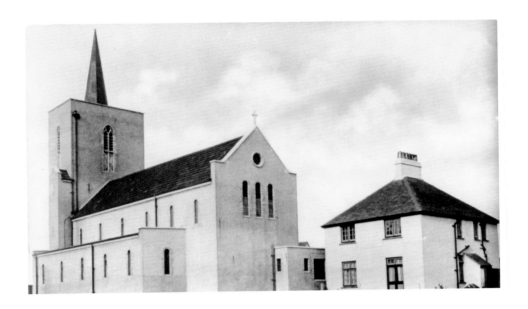

## Our Lady, Star of the Sea, Portslade

Mrs Catherine Broderick paid for the new Roman Catholic church at Portslade and it opened in July 1912. In 1992 the congregation of 150 people were distraught when a decision to demolish it was taken and an appeal was even made to the Pope who declined to intervene. New houses were built on the site in 1994.

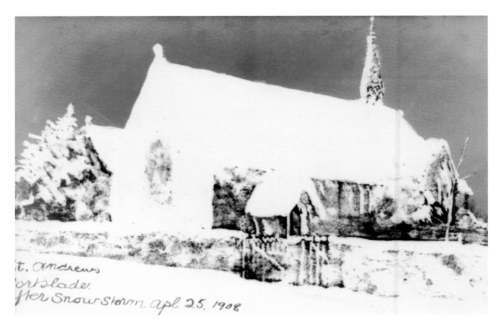

*t. andrews*
*ortslade.*
*fter Snow Storm apl 25, 1908*

## St Andrew's Church, Portslade

St Andrew's Church was dedicated in 1864 with the north aisle being added in 1890s. The April snowstorm of 1908 reminds us that the vagaries of English weather are nothing new. In 2004 the structure opened as a well-designed community centre on two levels with a small chapel in the old chancel. But several stained glass windows were removed.

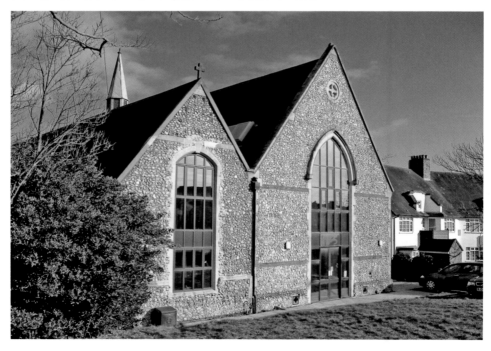

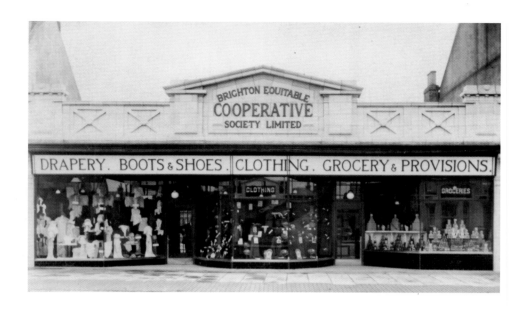

## Boundary Road

The Co-op building in Boundary Road dated from 1920 and lasted until the early 1960s. At each transaction the membership number was recorded manually and the annual Dividend Day was looked forward to with much anticipation. The site was sold to the Post Office.

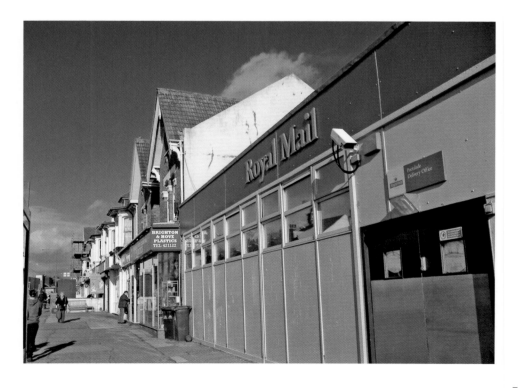

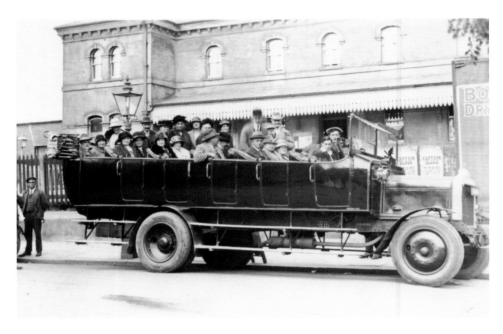

## Portslade Station

Portslade Railway Station dates from the 1880s – the earlier one was built west of the level crossing. The charabanc is lined up outside it in around 1927. The second photograph was taken in May 2003 when a colourful fruit and vegetable stall operated on the forecourt but sadly it is no longer there.

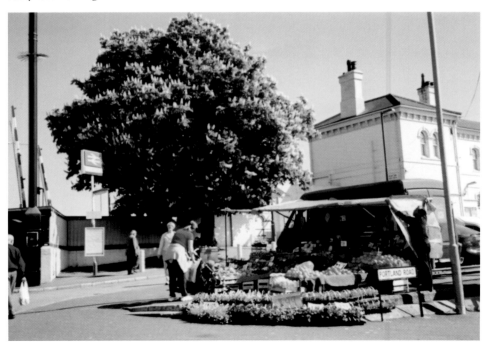

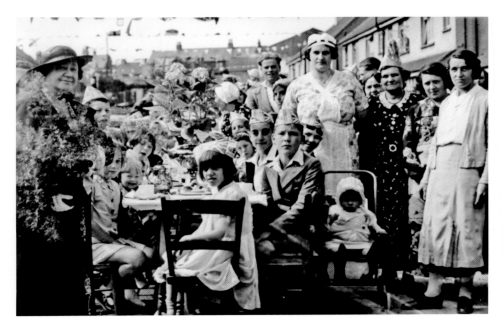

## Wolseley Road, Portslade

A well-attended street party was held on 12 May 1937 in honour of the coronation of King George VI and Queen Elizabeth. Wolseley Road, Portslade was the most probable location and the small roofs over the bay windows match up with the recent photograph.

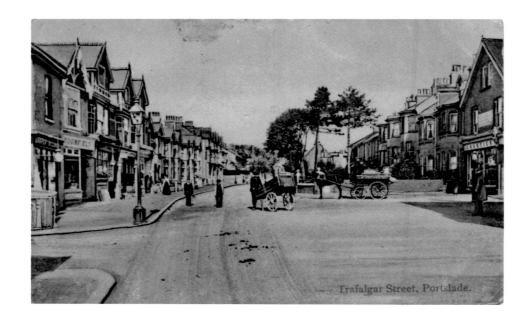

Trafalgar Street, Portslade.

### Trafalgar Road, Portslade

Trafalgar Road was pictured in around 1905 with Coustick's bakery on the right – the building now occupied by a Hindu temple. Coustick's horse and van are in front of the fir trees. This quiet road has turned into one of the busiest thoroughfares in the area, augmented by heavy lorries from Shoreham Harbour.

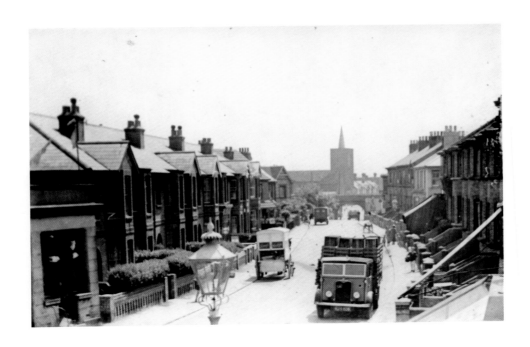

## Trafalgar Road Looking South

In this 1950s' postcard of Trafalgar Road the spire of the Catholic Church can be seen in the distance. Note the gas lamp and the horse drawn van. The Battle of Trafalgar pub dates from the 1860s and in 1900 an inquest was held there on a labourer killed in the nearby flint pits.

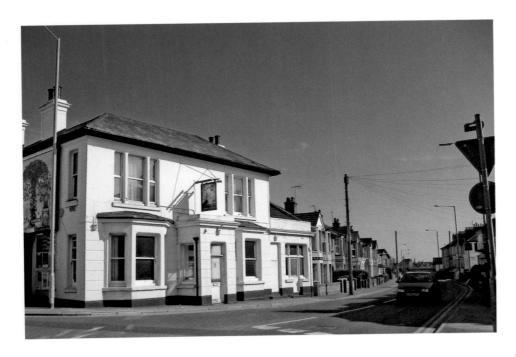

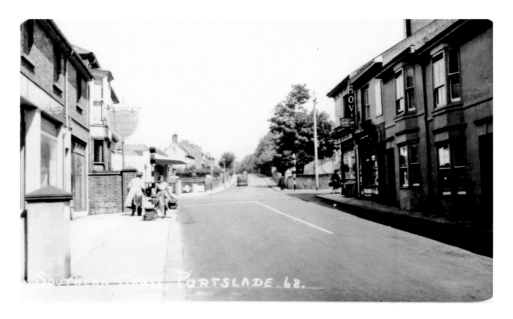

## Trafalger Road Looking North

The part of Trafalgar Road shown in this view has changed drastically. All the buildings plus the Southern Cross pub were swept away in the 1970s for road widening. The second photograph shows the extended carriageway from further down the road with the house on the right dating from the 1920s.

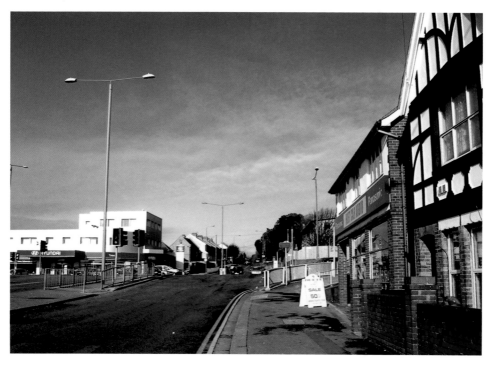

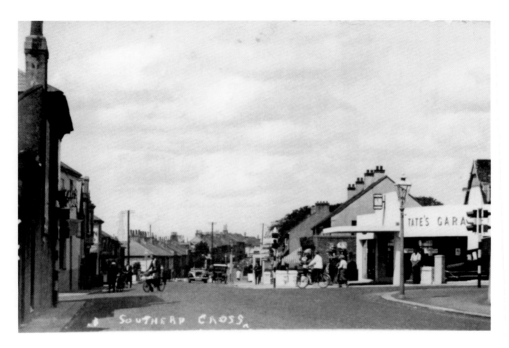

## Old Shoreham Road and Southern Cross

This postcard dates to the 1930s. Note Tate's garage on the right. It opened in 1919 and is still going strong today and remains family owned. The recent photograph shows the refurbished frontage completed in 2008.

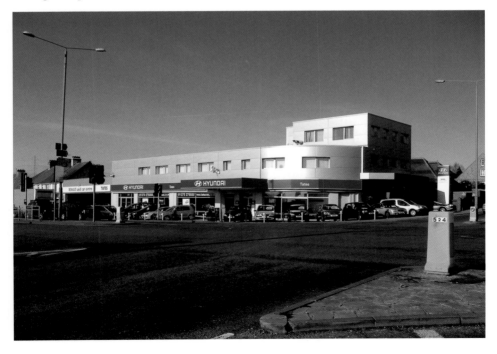

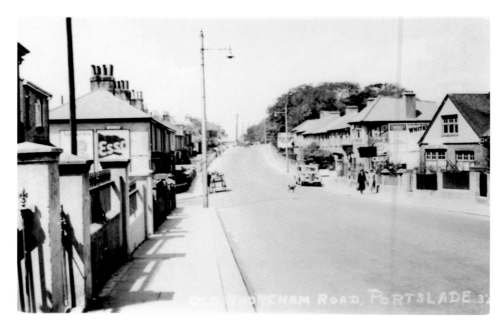

## Old Shoreham Road Looking West

The Old Shoreham Road captured in around 1950 looks so peaceful as to be unrecognisable. Note the dog feeling quite safe dawdling in the middle of the road. The houses on the left were demolished in the 1970s when the road was widened but the houses on the north side remained.

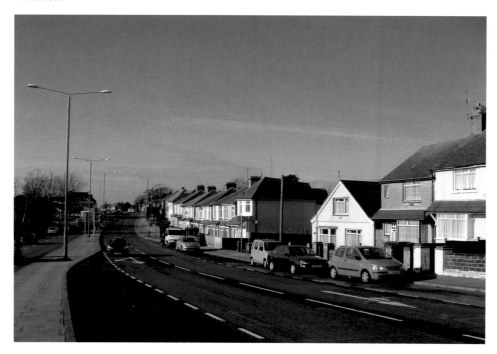

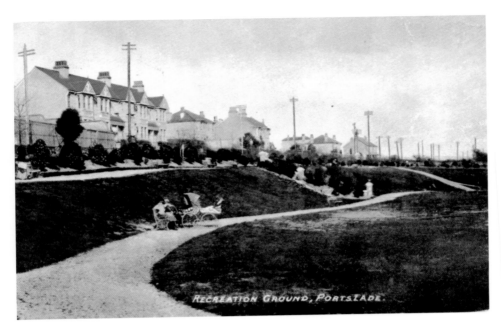

RECREATION GROUND, PORTSLADE.

## Victoria Recreation Groud

Victoria Recreation Ground opened on 11 August 1902, the same day as the coronation of Edward VII. It was the first public green space in Portslade. The postcard dates from 1909 while the recent view was taken in 2009. The trees on the bank in the background have grown up rapidly – there were none there in the 1960s, but the gabled houses in the Old Shoreham Road can just be seen.

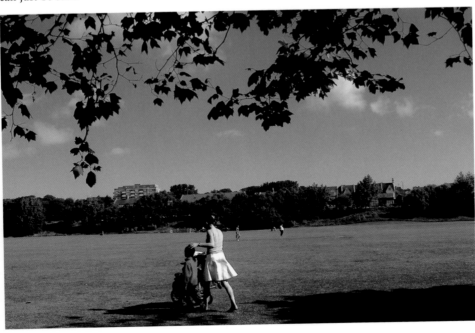

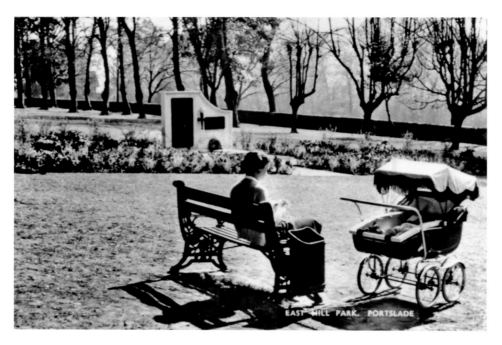

## Easthill Park

Easthill Park once belonged to a private house and it only opened to the public in 1948. The war memorial was moved there in 1954 from its old location outside the British Legion Hall in Trafalgar Road. It was no longer a suitable place to hold a Remembrance Day service.

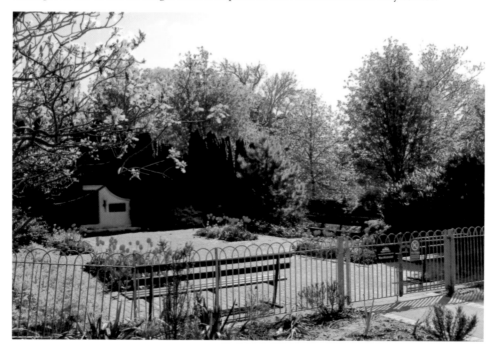

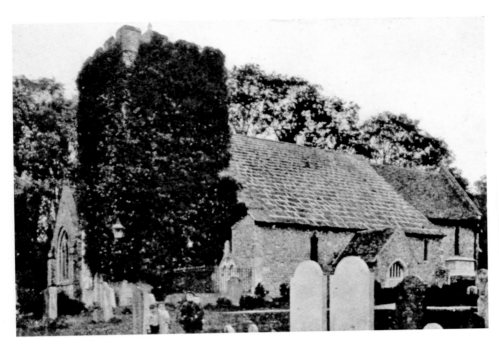

## St Nicolas's Church

St Nicolas's is the only ancient church in Hove and Portslade to have been in constant use since its foundation in 1170. Closely associated with the old church was Portslade Manor House built nearby. It is well known that Victorians thought ivy-covered towers romantic but the message on the back of the postcard was dated 1918.

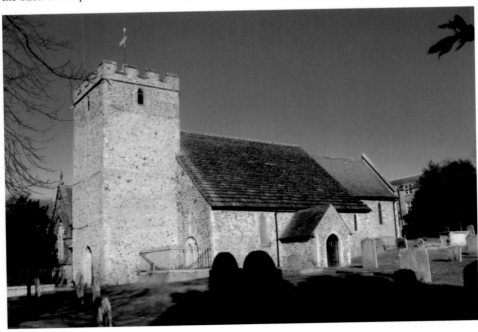

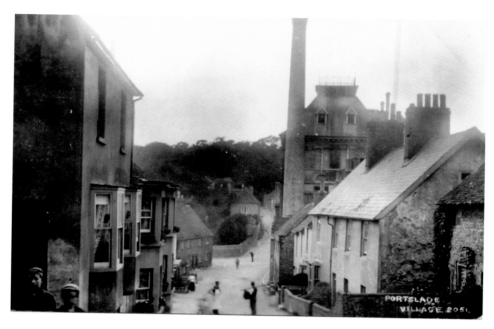

## Portslade Old Village

The old postcard of the High Street is rather dark and forbidding. The boys on the left stand at the entrance to Hangleton Court where in 1891 some forty-six persons lived squashed into eight small flint cottages. Those cottages have gone as well as the ones next to the brewery but fortunately others survive and they are highly prized today.

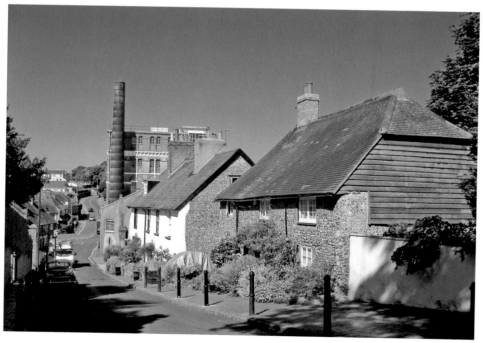

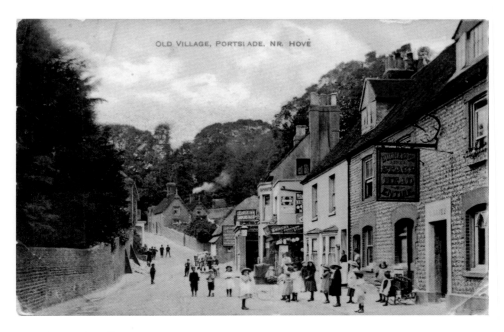

## Portslade Old Village

This enchanting postcard dates from 1906 when George Davey was landlord of the Stag's Head and Isaac Holland ran the George Inn. Smoke curls up from one of the chimneys of Swiss Cottages. The second photograph was taken in June 2009. The steep slope of the Stag's Head and adjoining cottages indicate that they were once thatched.

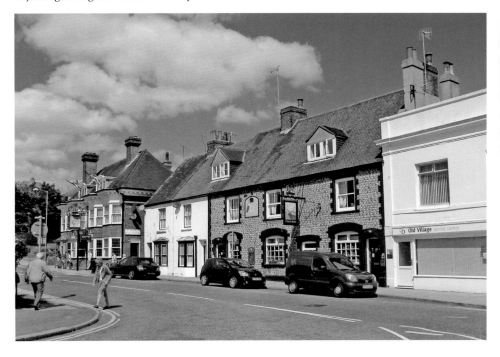

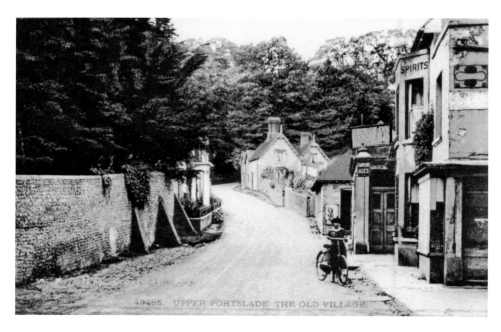

## Portslade Old Village with the George Inn

The earlier view shows the George Inn before it was rebuilt in the 1930s. If you went down the twitten by the pub door, you would have found Fraser's Court, a group of eight old flint cottages. On the left the shored up flint wall and porch belong to Portslade Grange in whose gardens peacocks once strutted.

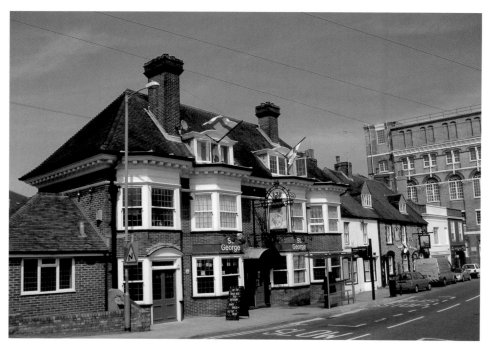

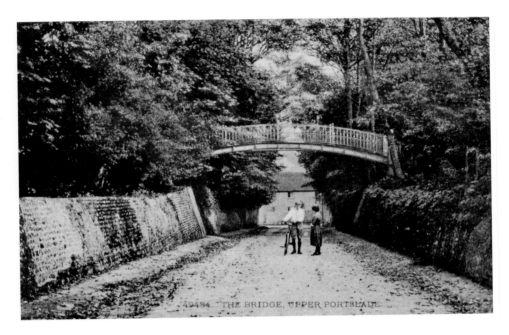

## High Street and Bridge

The bridge spanning the High Street was a celebrated local view and there are several different postcards to prove it. The bridge connected the two parts of the Portslade House estate. Unhappily by the 1930s nobody wanted to take responsibility for its upkeep, certainly not Portslade Council and it was demolished in 1948. The flint wall on the north side was breached when High Close was built in the 1930s.

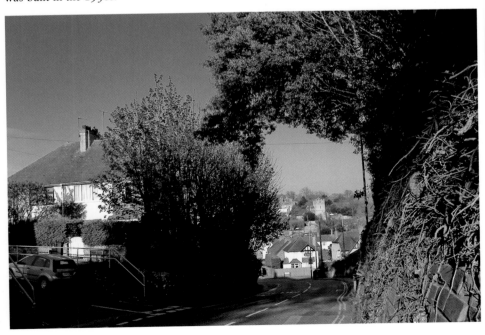

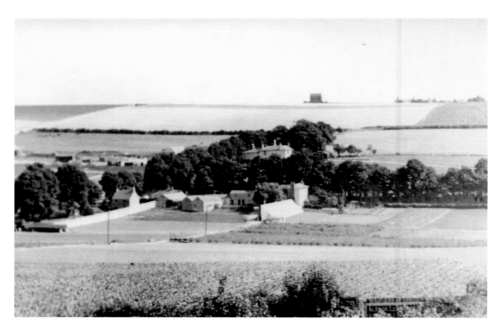

## Mile Oak and Foredown Tower

This nostalgic postcard shows rural Portslade before the onslaught of bricks and mortar. Trees shelter North House Farmhouse while the Stonery market garden is in front. On the skyline is Foredown Tower built in 1909 as a water storage unit for the isolation hospital. The later view dates from 2003.

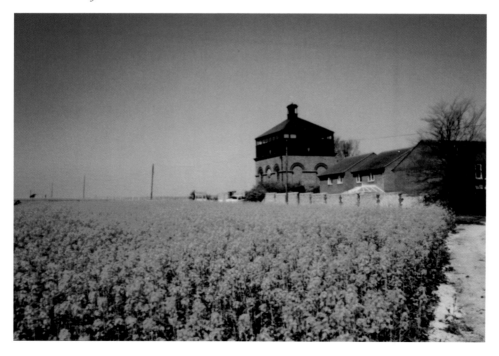

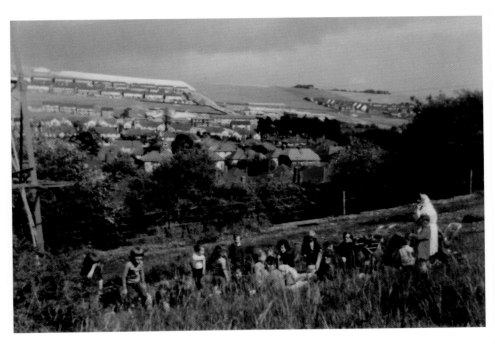

## Mile Oak – the View From Southwick Hill

The first photograph was taken in 1972 when a group of St Nicolas's Young Wives and their children were enjoying a picnic on Southwick Hill. In the recent photograph you can still make out Foredown Tower on the skyline but new housing is also evident.

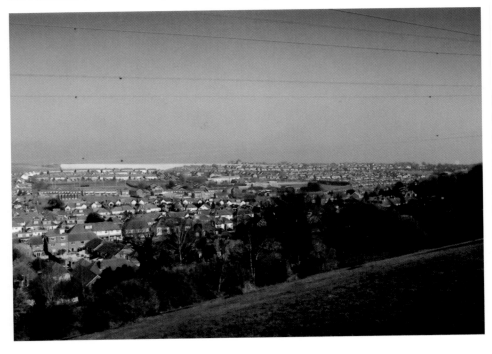

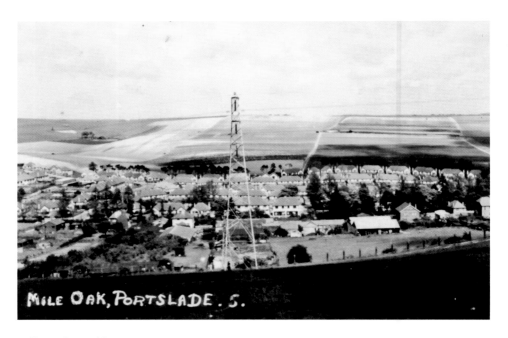

## Mile Oak Looking East

Mile Oak started to be developed in the 1930s despite the fierce opposition of local farmer John Broomfield. Note too the recently erected electricity pylon. New England Farm is in the background on the left. The second view shows the astonishing growth of Mile Oak. It was much favoured by young married couples and so was nicknamed Nappy Valley.

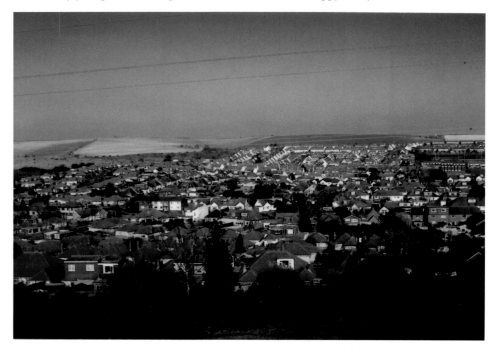